ART IN THE EIGHTIES

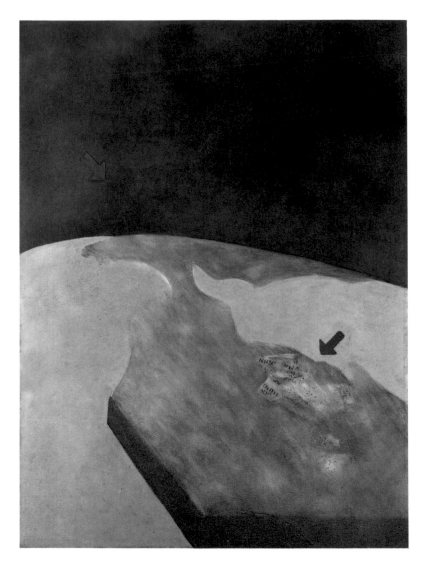

Francis Bacon. *A Piece of Waste Land*. 1982. Oil on canvas,
198 × 147.5 cm (78 × 58 in). Courtesy Marlborough Fine
Art, London

1 9 8 0

1 9 8 1

1 9 8 2

Edward Lucie-Smith 1 9 8 3

A R T I N T H E E I G H T I E S

1 9 8 4

1 9 8 5

1 9 8 6

1 9 8 7

1 9 8 8

PHAIDON · OXFORD
PHAIDON UNIVERSE · NEW YORK
1 9 8 9

To Susan and Robert Summer

Published in Great Britain by Phaidon Press Limited, Musterlin House, Jordan
Hill Road, Oxford OX2 8DP

ISBN 0 7148 2609 X Hb
ISBN 0 7148 2610 3 Pb

A CIP catalogue record for this book is available from the British Library

Published in the United States of America by Phaidon Universe, 381 Park
Avenue South, New York, N.Y. 10016

ISBN 0-87663-600-8

A CIP catalog record for this book is available from the Library of Congress

First published 1990
© Phaidon Press Limited 1990
Text © Edward Lucie-Smith 1990

Book design by James Campus

Phototypeset by Tradespools Ltd., Frome, Somerset
in Linotype Garamond 3
Printed in Spain by H. Fournier S A, Vitoria

CONTENTS

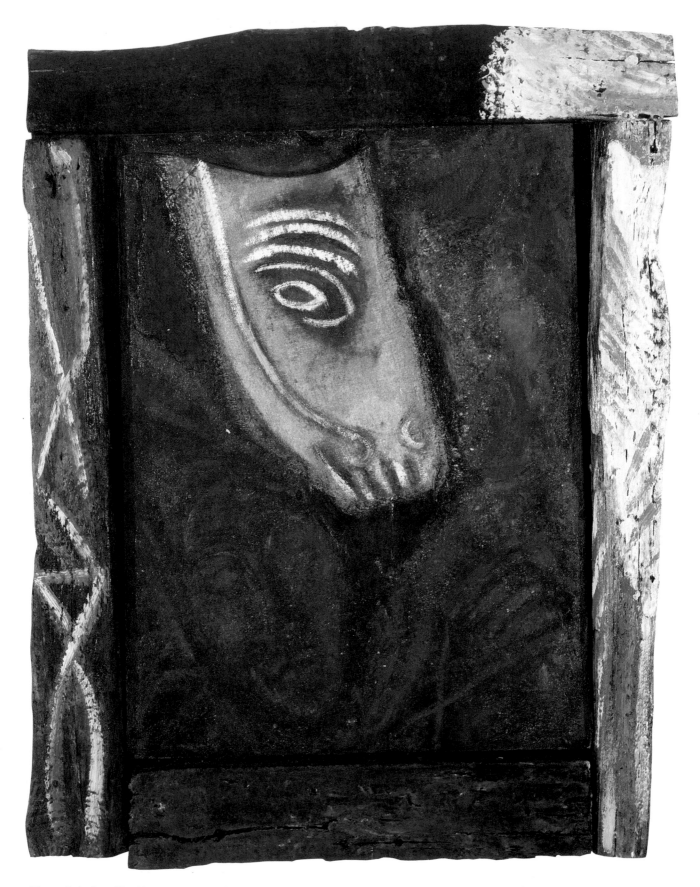

Mimmo Paladino. *Noa Noa.* 1983. Oil on panel,
53 × 40 cm (21 × 15³/₄ in). **Private Collection**

INTRODUCTION: THE NEW SPIRIT IN PAINTING

On 15 January 1981 the Royal Academy of Arts in London, not hitherto noted for its whole-hearted support of the avant-garde, and situated in a country where the critics and exhibition-going public were both still slightly suspicious of modernism, a new show opened entitled *A New Spirit in Painting*. The exhibition was an attempt to predict what would seem artistically important during the decade to follow. Like all such attempts, it was only partially successful. Nevertheless, its inclusions and omissions were highly significant for the art of the 1980s.

The first thing to notice about *A New Spirit in Painting* is the emphasis on 'painting'. During the 1970s it had often seemed as if the traditional distinction between painting and sculpture was about to be abolished. Art 'at the cutting edge' (I think this phrase was already current) paid little heed to whether work was two-dimensional or three-dimensional. When they were completely free to make a choice, artists almost instinctively opted for the greater freedom of three-dimensionality – and also for what they felt to be the greater honesty of work from which any pretence at creating an illusion had been banished. Where the re-creation or reconstruction of three-dimensional appearances upon a flat surface actually occurred, it tended to be regarded with suspicion. The exhibition at the Royal Academy asserted that the separation between the genres continued to be a valid one, and that there were indeed things which a painter could accomplish and which a sculptor could not do.

An analysis of the actual contents of the show yields information of great interest. Thirty-eight artists were included. Some had been major stars for a long time – Francis Bacon, David Hockney, Willem de Kooning, Matta, Pablo Picasso, Frank Stella, Andy Warhol. Some were senior figurative artists who up to this point had seemed a little isolated from what post-war modernism was really about – Balthus and Lucian Freud. Some were Minimalists, practitioners of one of the best-established art styles of the late 1960s and 1970s – these included Alan Charlton (British), Gotthard Graubner (German), Brice Marden and Robert Ryman (both American). There were also members of the *Arte Povera* group which had flourished in Italy during the same period – Pier Paolo Calzolari, Jannis Kounellis, Mario Merz.

Markus Lüpertz. *Occupier: Midday (Das Collier des Siegers).* 1983. Oil on linen, 165 × 133 cm (65 × 52¹/₂ in). Courtesy Mary Boone Gallery, New York

There were also a number of inclusions which helped to give *A New Spirit in Painting* a novel and revolutionary tone. In the first place, there was a large group of German artists, whose work was loosely related to the old German Expressionism of the pre-World War I and Weimar years – Georg Baselitz, Rainer Fetting, K.H. Hödicke, Anselm Kiefer, Bernd Koberling, Markus Lüpertz, A.R. Penck, Sigmar Polke. Most of these artists were already much exhibited in Germany itself, but for the majority the Royal Academy exhibition marked their international breakthrough. More than half had not exhibited on such an acknowledged level previously – that is, with the likes of Bacon, de Kooning, Stella and Warhol. To this group of Germans were added artists of other nationalities whose work looked a little like theirs. Among them were Sandro Chia and Mimmo Paladino (Italian), and Julian Schnabel (American). For most critics, these inclusions were the most important aspect of the show.

Jannis Kounellis. *Installation at Walcot Chapel, Bath*.
Artsite Gallery, Bath Festival Exhibition 1987

Roberto Marquez. *Mirrors Have No Mercy*. 1988. Oil on canvas,
152 × 183 cm (60 × 72 in). Courtesy Riva Yares Gallery, Scottsdale Arizona

Sandro Chia. *Water Bearer*. 1981. Oil and pastel on canvas, 200.7 × 170.2 cm (78³/₄ × 67 in). Courtesy the Tate Gallery, London

Rainer Fetting. *Susanne II Brown*. 1981. Acrylic on canvas, 175 × 150 cm (69 × 59 in). Courtesy Raab Gallery, London

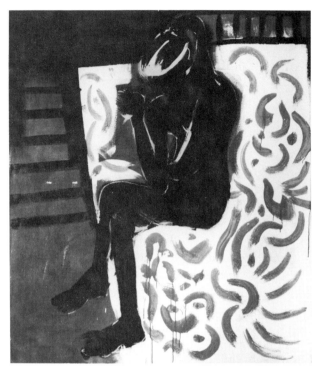

The excitement generated by the emergence of the German Neo-Expressionist school and its allies was so intense that few people realized that *A New Spirit in Painting* had also drastically rearranged the established hierarchies of British modernism. The show abruptly discarded the opposition between the British versions of Pop Art and of Post-Painterly Abstraction (work by members of the Situation Group, founded at the beginning of the 1960s), in favour of a new 'School of London' – the phrase had been coined in 1976 by the British-domiciled American, R.B. Kitaj. The School of London spanned several generations. It removed Bacon and Freud from their hitherto isolated situations, and put them at the head of a motley band which included Frank Auerbach, Kitaj himself and Howard Hodgkin. Later Leon Kossoff and Michael Andrews were to be proposed as additional members.

Despite the inclusion of a number of major artists from America, it is clear that the exhibition organizers believed that the creative energy was now more likely to be found elsewhere. Only nine Americans were included, two of them (Kitaj and Cy Twombly) permanently domiciled in Europe, whereas there were no fewer than eleven Germans. Within Europe, the emphasis was heavily on Nordic countries. There were only two Frenchmen (Balthus and Jean Hélion), plus a Frenchman-by-courtesy, Pablo Picasso, who in any case was no longer alive. Set against the general development of post-war modernism,

from Abstract Expressionism onwards, all this marked a radical change of direction. New York was no longer the force it had been; the old Ecole de Paris, which had survived into the 1950s, was quite definitively dead.

I have analysed the contents of *A New Spirit in Painting* in detail because the exhibition accurately prophesied the direction the visual arts would take in the course of the decade that followed. Some of its prophecies were self-fulfilling – they were bound to come about once they had been made. The controversy aroused by the decision to include so many new German artists propelled the whole German school into the limelight. German Neo-Expressionist artists became major international stars, at a level reserved during the previous three decades for the major artists of the school of New York and for almost no others.

It was agreed in many quarters that the creative initiative had indeed returned to Europe. It was not merely European artists, but also European critics, curators and museum directors who began to show a new independence. During the post-war epoch an exhibition circuit had been created in Europe, which had been one of

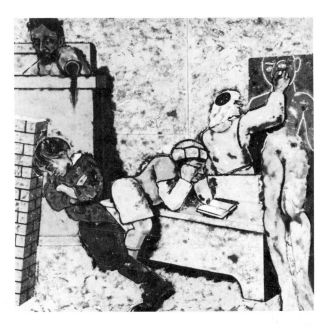

the chief means of disseminating the message of American
art. It included a number of important German
museums, plus the Stedelijk Museum in Amsterdam, the
Kunsthalle in Basel, Modernamuseet in Stockholm and
the Louisiana Museum in Denmark. All of these insti-
tutions began to show increased interest in what was
happening on their own doorsteps – the emphasis was,
once again, on northern rather than southern European
artists. France suffered from a lack of forceful and
convincing new talents, with the result that the Centre
Pompidou in Paris pursued a policy which was oriented
towards survey shows of the earlier years of modernism –
the period when Paris had, indeed, been the centre of the
art world. In Italy there were many new artists and new
art movements but no major institution which regularly
staged avant-garde exhibitions. The Venice Biennale,
with its chronic lack of focus, was not an acceptable sub-

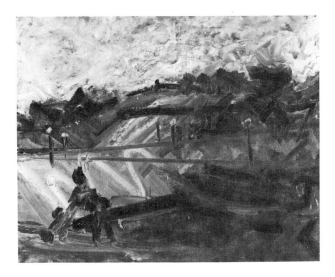

stitute. The gap was only filled towards the end of the
1980s, by the creation of a new exhibition centre at
Palazzo Grassi in Venice and a new Museum of Modern
Art at Prato. Showings of avant-garde art in London, div-
ided between the Tate Gallery, the Royal Academy and
the Hayward Gallery (the last under the direction of the
Arts Council of Great Britain and then of its successor,

the South Bank Arts Board), continued to be somewhat
erratic, but there was a provincial exhibition circuit of
growing ambition and interest.

If *A New Spirit in Painting* openly promoted the cause of
the new German art, it also put forward other significant
ideas, at least by implication. Both the choice of German
artists and the choice of British ones suggested that the
age of modernist internationalism was coming to an end.
All of the German Neo-Expressionists were deeply con-
cerned with the idea of what it was to be German. They
tackled German traumas and explored German cultural
roots. The British exhibitors were not as consciously and
vehemently nationalist, but the choice of painters and
paintings seemed to suggest that there was a growing pre-
occupation with specifically British qualities. British Pop
(entirely absent apart from David Hockney, who showed
work which had very little connection with the Pop
movement) had, on the contrary, tended to stress the
many links between British and American mass culture,
and the homogeneous character of industrial society taken
as a whole.

Even more significant was the pluralism of the show.
The things which the Minimalists tried to communicate
were so different from those which preoccupied the
figurative painters shown side by side with them that it
seemed as if a completely different critical language was
required to assess their work. All pretence vanished that
contemporary art possessed intellectual unity however
different the guises in which it presented itself. More im-
portantly, *A New Spirit in Painting* undermined the theory
that modernism in the post-World War II epoch had con-
sisted of a dialectic of styles, with each new movement

taking up and then either enlarging upon or refuting the arguments put forward by its immediate predecessor. Here were works of art made at the same point in time, and hung, as it now happened, in the same building, but with essentially nothing to say to one another.

One of the ways in which the artistic climate has changed most markedly since the exhibition is in the huge and sudden expansion of the universe of contemporary art. Since 1981 there has been a plethora of exhibitions devoted to Latin American art, and an almost equal plethora devoted to art from the Soviet Union. Both of these phenomena put the Western European or North American critic into difficulties. Latin America has been producing modernist painting and sculpture since the beginning of the 1920s. But this activity was for a long time overshadowed by the Muralist movement in Mexico, which borrowed certain ideas from early modernism without itself being fully modern. One of the chief things it retained from the nineteenth century was the notion that the artist could not be part of an elite but must be a fully participating member of a mass society. The Russian Constructivists also professed this ideal; but it was figurative Mexican artists such as Diego Rivera and José Clemente Orozco who came much closer to fulfilling it.

The prolonged success of the Muralist movement planted the idea that Latin American art was essentially the product of a mixed, non-European culture, and a retort to European colonialism. This is an explanation which partially fits the facts in Mexico, the cradle of Muralism, but which is utterly implausible when applied to the art of countries such as Chile or Argentina, or even Venezuela. It cannot be denied that art plays an important public role in Latin American culture, and that the Latin American element is increasingly making itself felt as a real presence in the United States, where it has become symbolic of the emergence of a new, distinctively Hispanic culture. But European and North American interpretations of the Latin American art of today too frequently try to force it into a mould which was broken when Muralism died in the 1960s.

If there is one theme which seems to be important in the Latin American art of the 1980s, it is the emergence of a form of 'magic realism' which is equivalent to the strange mingling of realism and fantasy in the work of the

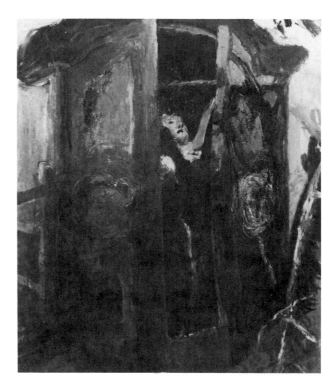

Jacobo Borges. *A.* 1988. Oil on canvas, 168.5 × 142 cm (66¹/₄ × 56³/₄ in). cm (Courtesy CDS Gallery, New York

novelist Gabriel Garcia Marquez. This dream-like, yet totally veracious quality can be found in the work of artists otherwise as different from one another as José Gamarra of Uruguay (b. 1934) and Jacobo Borges of Venezuela (b. 1931). It is also conspicuous in the art of leading younger Mexican painters such as Alejandro Colunga (b. 1948) and Roberto Marquez (b. 1959). Significantly, these younger Mexicans owe more to the example of Rufino Tamayo (b. 1899) and to the continuing strength of Mexican folk art and custom than they do to the Muralists.

It used to be a cherished shibboleth of Western culture that the only art of the slightest interest produced in the Soviet Union was the work of artists who were completely alienated from Soviet society. Critics in the West were, nevertheless, disappointed by the exhibitions of 'unofficial' Soviet art which found their way to the other side of the Iron Curtain. The most substantial of these exhibitions is commemorated by the book *Unofficial Art from*

the Soviet Union by Igor Golomshtok and Alexander Glezer, published in 1977. The text often makes curious reading in the new era of *glasnost*. However, one aspect of it remains relevant, and this is the fact that it illustrates a great medley of different styles and approaches to art, seemingly without any organic connection with one another. Now that the climate has changed so dramatically, and there is an immense and ever-increasing interest in Soviet artists of all kinds, from the most conservative (whose products are sometimes regarded as inexpensive substitutes for the Impressionists) to the most experimental, the hierarchy of development remains unsettled. It is at the moment impossible for a Western critic to tell for certain which Russian artists are to be regarded as important stylistic innovators, and which are mere camp-followers.

On the other hand, the hierarchy of American and Western European artists grows increasingly rigid, and more and more tends to be computed in terms of financial value. One of the most striking, if not one of the most reassuring artistic events of the 1980s occurred when a work by a living artist, *False Start* by Jasper Johns (b. 1930), fetched a price in excess of $17 million, ranking him as the author of one of the ten most expensive paintings ever sold at auction. In the circumstances, contemporary art can hardly complain of lack of status.

GERMAN NEO-EXPRESSIONISM

The new figuration has been more consistently associated with German artists than with those of any other national school. This association is natural enough, since the original Expressionism of the period just before and after World War I (which the new style often closely resembled) had been specifically German. Though the German Expressionists of the early modernist period undoubtedly owed something to the French Fauves, Matisse in particular, they were also conscious of deep roots in the German past. Their powerful woodcuts, for example, demonstrate their debt to the impassioned German art of the Late Gothic.

There is a kind of paradox about the revival of Expressionism in Germany which has been very little understood by non-German critics. Commentators point to the long period following World War II during which Germany, despite her rapid economic recovery and the accompanying revival of cultural activity, remained in thrall to foreign styles. They suggest that the return to national roots was very belated and that when it took place there was a sudden and complete stylistic revolution.

If this is true at all, it is only true of what happened in the Federal Republic. The revival of Expressionist painting in East Germany began very soon after the war. There were particular reasons for this revival. Expressionism had been condemned by the Nazis – the Expressionist style was what they meant to point to when they denounced the 'decadence' of modernism. The Exhibition of Degenerate Art staged in Munich in 1937 contained examples of other modernist styles, but was essentially the largest exhibition of Expressionist painting and sculpture ever to have been held in Germany up to that time.

Quite apart from their purely visceral distaste for Expressionist art, the Nazis had perfectly good political reasons for detesting it. The horrors of World War I had had the effect of politicizing the German avant-garde, and the so-called 'Second Expressionism' of the period after the war placed much greater emphasis on radical political content than the experimental art of the pre-war epoch. Paradoxically, the memory of this aspect of Expressionism may have militated against an immediate revival of the style in West Germany after World War II. German artists were tired of politics, and the Weimar Expression-

ists seemed too strident, and also too poignant a reminder of the dark years Germany had endured. This was not the case in the East, where the Communist regime, anxious to stress its own continuity with the heroic days of German Marxism in the 1920s and on the look-out for an effectively propagandist art, found it natural to pick up the threads of an artistic development which had been severed by Hitler's rise to power.

Werner Tübke. *Three Women*. 1983. Oil on canvas, 150 × 150 cm (59 × 59 in). Courtesy Schlesinger Gallery, New York

The two artists most favoured by the East German regime from the mid-fifties onward were Werner Tübke (b. 1929) and Willi Sitte (b. 1921). Tübke's work, heavily indebted to Dürer, Altdorfer and Hans Baldung Grien, anticipated attitudes which were to be of great importance to many non-Communist artists in the 1980s, though in this case the similarities were probably coincidental. Things were different with Willi Sitte, a powerful painter whose work is an eclectic amalgam of the Picasso of the 1940s and 1950s, Renato Guttuso and the German artists of the Second Expressionism. Sitte's art is strident and occasionally vulgar, but it is undoubtedly a powerful instrument of communication. The political propaganda

Willi Sitte. *Family On Sunday Morning*. 1973. Oil on board,
122 × 170 cm (48 × 67 in). Courtesy Prakapas Gallery, New York

Georg Baselitz. *Double Painter*. 1987. Oil on canvas,
146 × 114 cm (57¹/₂ × 44⁷/₈ in). Courtesy Anthony d'Offay
Gallery, London

is often leavened with an effectively blatant eroticism.
The way in which Sitte sometimes foreshadows the West
German Neo-Expressionism of the 1970s and 1980s is
very striking.

The Expressionist revival in West Germany had its
start as early as the 1960s, though it was not noticed
much outside Berlin. It seems to have owed a great deal to
a knowledge of what was going on in the East. A pioneer
of the movement was Georg Baselitz (b. 1938), who was
born in East Germany and lived there until 1956. Baselitz
moved to West Berlin to continue his studies because he
had been expelled from the East Berlin School of Fine Arts
for 'socio-political immaturity'. But his early experiences
in the so called 'free world' were scarcely happier than
those he had had in the East. His first one-man show, held
at the Galerie Michael Werner in Berlin in 1963, caused a
tremendous scandal. The paintings he showed were figu-
rative and not very far in style from those being produced
at the same moment by Willi Sitte. The cause of offence
was not the style but the content – specifically, certain
erotic allusions.

These two experiences – his clash with the East Berlin
authorities, and then with the public prosecutor in the
other half of the city, seem to have given Baselitz a
permanent feeling of revulsion for all forms of political in-
volvement. As he said in an interview given in 1983:

Gradually the idea dawned on me that I could launch myself
into painting. I thought that to do a picture I did not necessarily
have to have an interesting subject. The object had no intrinsic
importance any more. So I chose insignificant things... The
object expresses nothing. Painting is not a means to an end. On
the contrary, painting is autonomous.

In the late 1960s Baselitz's practical reaction to this train
of thought was to begin painting pictures in which the
image was fractured or fissured; and then to paint every
image upside down. Baselitz differs from German Neo-
Expressionists younger than himself in his insistence on

the formal qualities of the work – on its identity as paint.

As the Neo-Expressionist style developed in Germany,
and specifically in Berlin, this attitude of political detach-
ment could not be maintained. Sometimes political sym-
bols were used in a relatively unspecific way, as for
example in some of the *Dithyramb* paintings produced by
Markus Lüpertz in the 1970s and 80s, which make play
with typically German motifs such as the helmet, the ear
of corn and the military cap. Sometimes the political
message is clear and detailed, as in the *Café Deutschland*
series by Jorg Immendorf (b. 1945), which comment
upon the division of Germany. These artists were, in any
case, responding to an increasing political polarization
within West Germany itself.

A much richer and subtler political content appeared in
the work of Anselm Kiefer (b. 1945). Kiefer, though still
under fifty, is generally considered to be the most import-
ant living German artist, certainly since the death of his
own mentor, Joseph Beuys (1921–86). A full generation
younger than Baselitz and from West, not East Germany,

Georg Baselitz. *Still no Snow.* **1988. Oil on canvas, 162 × 130 cm**
(63³/₄ × 51¹/₈ in). Courtesy Anthony d'Offay Gallery, London

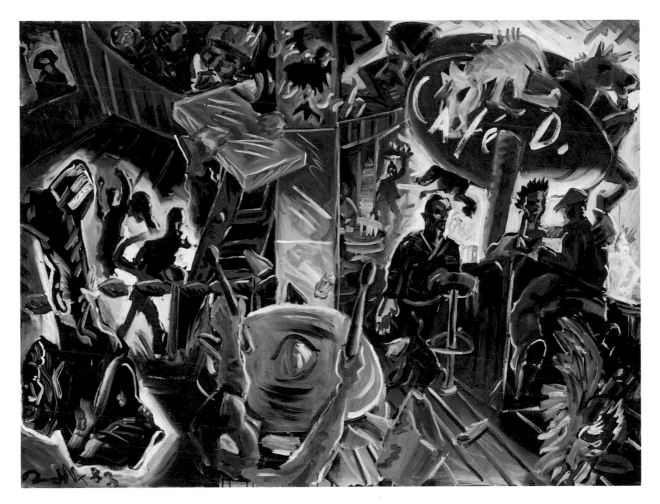

Jorg Immendorf. *Cafe Deutchland Horerwunsch.* **1983. Oil on canvas, 150.3 × 200.8 cm (59¹/₄ × 79¹/₈ in). Private Collection**

Anselm Kiefer. *The High Priestess* (detail). 1985–9. Photographs mounted on treated lead, 75.5 × 52 × 11 cm (29³/₄ × 20¹/₂ × 4¹/₂ in). Courtesy Anthony d'Offay Gallery, London

he is more representative of what has happened to the Neo-Expressionist impulse in the German art of the 1980s. Unlike Baselitz, Kiefer never experienced the war, even as a child. Despite this lack of direct contact with traumatic events, his constant preoccupations are with the German past, with the fate of German culture, and with the heritage of Nazism.

Kiefer studied with Beuys from 1970 to 1972, and is his direct heir. However, instead of seeking completely new forms, as Beuys did throughout his career — rituals and happenings, and even direct political action — Kiefer has tried to revive traditional formats. In particular, he has given new life to a form of expression long considered obsolete: the large painting which is not a decoration but a considered public statement. The best comparisons for some of Kiefer's recent major works are Géricault's *The Raft of the Brig 'Medusa'* and Delacroix's *Massacre at Chios*, which are comments on contemporary politics of exactly the same kind.

Kiefer is notoriously reluctant to supply biographical facts about himself, and forbids direct quotation from any interviews that he gives. However, a brief and quirky 'Autobiography' written in 1976 (a chronological list of names and events covering about a page) makes it plain that his intellectual progress has been increasingly a matter of searching for his own identity as a German. In the 1960s, when Kiefer was still a student, he was able to travel widely, and his first heroes were either non-Germans such as van Gogh and Rodin, or else German cosmopolitans like the poet Rainer Maria Rilke. Kiefer has always been attracted towards what are, in German terms, dangerous areas. In the 1970s some of his work uses images taken from the operas of Wagner and the Norse Edda on which *The Ring* cycle is based. He also painted a series of pictures mythologizing enterprises of the German high command during the war — for example, Operation Sea Lion, a scheme for the invasion of England. The works in this particular series are a mixture of tones — simultaneously ironic and heroic. For instance, Kiefer recalls the fact that naval operations were sometimes planned using toy ships in a bathtub.

During this period Kiefer established himself as a landscape painter of sombre power. The devastated terrain which he so often depicted was a sacrilegious yet, at the same time, reverential gesture directed towards the mystical love of nature which is deep-rooted in German Romantic poetry and painting. Despite the disparity of scale, resemblances exist between Kiefer's work and that of Caspar David Friedrich, the leading German landscape painter of the Romantic epoch, whose work always carries strong symbolic overtones.

In the 1980s one major theme to which Kiefer returned repeatedly was the memory of the Holocaust. Many paintings use imagery taken from the poem *Todesfuge (Death Fuge)* written in a concentration camp in 1945 by the Romanian Jewish poet Paul Celan. Celan, the only member of his family to survive the camps, committed suicide in 1970. Two of the chief images in the poem are golden-haired Margarete, the personification of Aryan beauty, and Shulamith the Jewess, 'ashen-haired' because she has been cremated in a concentration-camp oven. Later in the 1980s Kiefer found another source of imagery in the overbearing neo-classical architecture designed for Hitler by Albert Speer and others, sometimes combining this theme with that of Margarete and Shulamith.

One of the ways in which Kiefer demonstrates his continuing kinship with Beuys is through his use of unortho-

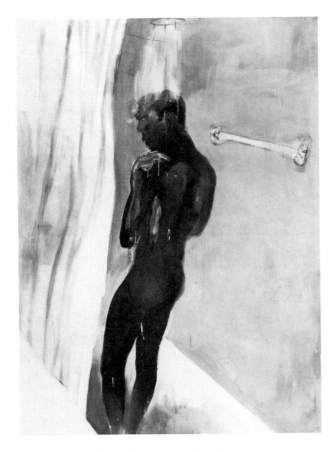

Rainer Fetting. *Shower II*. 1980. Powder paint on cotton, 220 × 160 cm (86¹/₂ × 63 in). Courtesy Anthony d'Offay Gallery, London

dox materials. Beuys employed fat and felt, substances which had both symbolic and autobiographical meaning for him – their connotations included warmth, energy and protection. Kiefer's chosen materials include straw and lead. The latter has alchemical significance, and alchemy is one of Kiefer's long-standing interests. For him, the making of a work of art is a transformation of physical realities through occult means, of the kind attempted by medieval alchemists.

Rainer Fetting (b. 1949) is close to Kiefer in age, but is a far more traditional kind of artist, who perhaps demonstrates that the level of intensity present in Kiefer's work cannot be reliably sustained. Where Fetting excels is in the virtuoso handling of paint. His subject-matter covers most of the traditional genres – portraiture, nudes, landscape and cityscape. Some paintings make use of collaged elements, but this is not standard practice with Fetting as it is with Kiefer. Compared to those of the original Expressionists, Fetting's paintings, influenced by American post-war trends, are very large. The likeness between his work and that of 'classical' Expressionists – for instance Kirchner – is therefore much more striking in reproduction than it is in reality. What reads as intensity and inner agitation when seen on a small scale becomes suave and operatic on a larger one. In some of Fetting's recent cityscapes there is a telling likeness to paintings by Kokoschka using similar subject-matter. This points to a significant general resemblance. Kokoschka, an Austrian with close ties to the Dresden-based Expressionism of *Die Brücke* (a city where he in fact settled and worked for a while), began working as a very specifically Germanic artist but finished as a cosmopolitan. Fetting has followed the same path and now spends much of his time in New York. His work never possessed much political content and now almost entirely lacks it, apart from his continued protest about the existence of the Berlin Wall. The predominant impression one takes away from his recent paintings is that of an artist very much at ease with the society he inhabits.

The development and reception of German Neo-Expressionism from Baselitz to Fetting seems to form a complete trajectory – from total rejection to the fullest international acceptance. The huge success enjoyed by their elders has made things difficult for German artists of

Rainer Fetting. *Embrace at the Pier*. 1987. Oil on linen,
228 × 182 cm (89³/₄ × 71¹/₂ in). Courtesy Raab Galleries,
Berlin/London

Thomas Schindler. *Aperlude.* 1982/4. Oil on canvas,
200 × 160 cm (78³/₄ × 63 in). Courtesy Raab Galleries,
Berlin/London

Thomas Schindler. *Drinker I*. 1987. Oil on canvas, 210 × 180 cm (82¹/₂ × 70³/₄ in). Courtesy Raab Gallery, London

Peter Chevalier. *The Day*. 1987. Oil on canvas, 161 × 200 cm (63¹/₂ × 78³/₄ in). Courtesy Raab Gallery, London

the newest generation, for whom Neo-Expressionism has inevitably become a kind of academic art. The most successful work produced by German artists born in the 1950s looks rather subdued in comparison to that done by their immediate predecessors. Peter Chevalier (b. 1955) and Thomas Schindler (b. 1959) are good examples of this newer and less fluent style. Both seem to have been influenced by the mysterious allegories of Max Beckmann. But there are also traces of the impact made by the later work of Giorgio de Chirico, and perhaps also that of

the Italian artists of the Trans-avantgarde. If one compares their work to that of Fetting, the general idiom is harsher and more linear, but with numerous allusions to classical forms. There was a similar development in Weimar Germany when Expressionism was challenged by the artists of the *Neue Sachlichkeit* (New Objectivity). However, both Schindler and Chevalier prefer fantastic, poetic subject-matter and show no trace of the political and social concerns which typified the art of the Weimar period and resurfaced in some Neo-Expressionist art.

ITALIAN TRANS-AVANTGARDE

Trans-avantgarde (in Italian *Trans-avant-guardia*) is a term invented by the Italian critic Achille Bonito Oliva and first used by him in an article published in the periodical *Flash Art* in the autumn of 1979. In 1980 Bonito Oliva published a book on the same theme. With these credentials, painting of the type he espoused may seem very much a phenomenon of the 1980s. The general inclination, encouraged by the inclusion of some of these Italian artists in *A New Spirit in Painting* and subsequent anthology shows following the same pattern, is to classify the movement as the Italian equivalent of German Neo-Expressionism.

This is not strictly the case. The work of the Trans-avantgarde painters can be related to problems which have preoccupied Italian artists almost throughout the century. In Italian terms it can be linked to the career of Giorgio de Chirico (1888–1978), and in particular to his later work. De Chirico is a difficult and ambiguous figure, a thorn in the flesh to many historians of modern art. He was active for a long lifetime, but the work he produced from the 1920s onwards has until recently been condemned by most critics. Even after de Chirico's death, it was given only token representation in the large retrospective exhibition organized by the Museum of Modern Art in New York in 1982 and afterwards shown at the Tate Gallery. A large number of late pictures did, however, appear in a revised version of the show which was seen in Paris and Munich. This accelerated the rehabilitation of the later de Chirico which Italian enthusiasts had begun in the 1970s.

To some extent, the neglect of de Chirico's later production was the artist's own fault. His rejection of his metaphysical period (the one the historians preferred), combined with his willingness to copy and sometimes even to fake the work of this epoch, persuaded people that anything he produced subsequently completely lacked integrity. Nor could they take seriously his strident claims that he had now returned successfully to the tradition of the Italian Old Masters. During the 1920s and 1930s de Chirico made playful use of 'antique' motifs, especially in the paintings of the *Gladiator* series, which showed classical figures battling in closed interiors, and in the *Mysterious Baths* which followed. Many of de Chirico's paintings of this time show the influence of

Sandro Chia. *Hidden Sex*. 1982. Oil and collage on panel, 126 × 113 cm (49¹/₂ × 44¹/₂ in). Courtesy Anthony d'Offay Gallery, London

Pompeian murals, not only in the themes chosen, but in a certain rapidity and sketchiness, and in a deliberate spatial discontinuity. Some examples have a very seductive air of chic; others, the Old Master pastiches especially, teeter on the edge of vulgarity, and quite often seem to fall over it.

The stylistic ambiguity of de Chirico's late work and his ironic attitude not only to the idea of the past but to the idea of 'quality' in painting seem to have exercised a great attraction over the members of the emergent Trans-avantgarde group. During the mid-1980s many other painters, especially in the United States, were to fall under the same spell.

The Trans-avantgarde artists, like each generation of Italian modernists before them, are extremely conscious of the crushing weight of the Italian past. Their painting tends to refer not to a single stylistic moment (as is the case with German Neo-Expressionism) but to all historic styles in general, as things to be interrogated, parodied

Sandro Chia. *I am a Fisherman*. 1984. Oil on canvas,
190 × 150 cm (74⁷/₈ × 50¹/₈ in). Private Collection

Francesco Clemente. *Paradigm*. 1988. Pigment on linen,
208 × 142 cm (82 × 56 in). Courtesy Sperone Westwater Gallery,
New York

Enzo Cucchi. *The House of the Barbarians.* **1982. Oil on canvas,**
312.4 × 212.1 cm (123¹/₂ × 83¹/₂ in). Private Collection

Mimmo Paladino. *Untitled.* **1988. Mixed media on wood,**
230 × 152.5 × 30 cm (90¹/₂ × 60 × 11⁷/₈ in). Private Collection

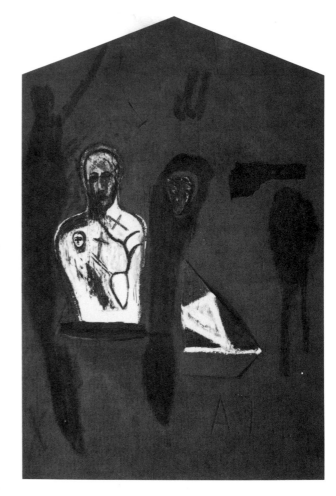

and disrupted. The clearest example is the work of Sandro
Chia (b. 1946). In an interview with Wolfgang Fischer
recorded in September 1987, Chia remarked:

The special capacity that an artist should have is to perceive
what is given as a cultural tradition, to perceive this cultural
reality in a more unconventional, outrageous way. It is his task,
and also his social duty, not to settle for the first definition of
tradition and culture, but to create the conditions for meta-
morphosis, a reconsideration of something that is already
present in some way, that already represents a possibility for
creation. It is his task to start a new creation from an existing
creation.

Chia puts this doctrine into practice by making art
which is an ironic commentary on the heroics of the past.
His paintings are frequently knockabout versions of class-
ical myths, with rolypoly nude figures which threaten to
turn into Michelin Men. The compositions are often
altered quotations from established masterpieces. Chia
sometimes adds an autobiographical element, and makes
the artist the hero of whatever story is being told. The
only Expressionist feature is the deliberate roughness of
the technique. Chia's bombast, mingled though it is with
flashes of ironic self-awareness, has created growing crit-
ical mistrust, and his reputation, created so rapidly in the
early years of the decade, looks increasingly insecure.

Francesco Clemente (b. 1952) casts his net much wider
than Chia. He has been interested in non-European cul-
tures since the beginning of his career. In 1975 he began
to spend long periods of each year in India, and he now
maintains a studio in Madras. Clemente experiments rest-
lessly with whatever techniques seem indigenous to the
place he is in, making woodcuts in Japan, trying to revive
the now almost-extinct methods of true fresco painting
when in Italy. His imagery, however, is very much of the
moment – a wild mixture of allusions to different cultures
and creeds. It is as if the contents of a dictionary of world
mythologies have been poured into a single pot and
stirred vigorously. Like Chia, Clemente frequently makes
himself the hero of his own story: self-portraits abound in
his production.

His work is more difficult to characterize than Chia's
simply because of its diversity of style and content, but
Clemente's own claims for it are considerable – he sees
himself as a kind of seer, on the model of some of the key

figures of early Romanticism. He praises Blake and
Fuseli, for example, for being 'the first western painters to
take a close look at bad taste, to see truth as bad taste'.
This begs the question of whether the concept of bad taste
has any reality outside the Western, and specifically the
Greco-Roman tradition. Clemente also expresses sym-
pathy with what he sees as the 'deliberate dilettantism' of
Giorgio de Chirico, and also of Francis Picabia (an artist
whose career followed very much the same pattern as de
Chirico's in the 1920s and 1930s, and who has been
regarded as another ancestor of 1980s 'bad painting'). All
this adds up to a subtle and provocative personality, but
Clemente is also an artist who produces far too much
which is derivative and superficial. Many of the Indian
works, for example, are little more than large-scale
pastiches of traditional Indian bazaar-painting,
significant only because they are part of the opening out
to non-European cultures which has been one of the
characteristics of the 1980s.

The third of the so-called 'Three Cs', Enzo Cucchi
(b. 1949), is the artist of the group who comes closest
to some aspects of German Neo-Expressionism, and
especially to the work of Anselm Kiefer. Like Kiefer, 'his

pictures depict, or incorporate actual references to, the elements of earth, water and fire, such as soil and charred wood.' These, we are told (the description comes from the biography of Cucchi in the catalogue of the great survey show of Italian twentieth-century art mounted at the Royal Academy in London in 1989), 'evoke the primeval and rejuvenating forces of nature, the cycles of death and destruction, rebirth and rejuvenation'. Such very large claims deserve to be met with a certain scepticism, and in fact Cucchi's work can sometimes be coarsely rhetorical. At his best, however, he is a powerful artist.

The most convincing of the Trans-avantgarde painters, somewhat isolated in style from the others, is Mimmo Paladino (b. 1948). Paladino comes from the south of Italy. He was born near Benevento and brought up in Naples, and he has remained attached to his roots there. His painting is historicist in a more focused and less frivolous way than that of Clemente and Chia. His primary sources are Italian: he draws on Greco-Roman, early Christian and Romanesque art, with an apparent preference for their more primitive and provincial manifestations.

Paladino takes his lead from these models by reducing his palette to oppositions of a few strong earth tones, plus black and white. Some paintings are monochrome, or all but monochrome. Christian subject-matter is often paraphrased. One favourite theme is a version of the Last Supper, but the feast is diabolized, so that it becomes a witches' conclave. The hints of the blasphemous, which are common currency in Paladino's work, go hand in hand with a kind of animism. Animals sometimes perform human actions, as they do in Romanesque church decoration. Paladino's paintings also celebrate a cult of death, with many representations of skeletons, death's heads and bogies of all kinds. The result does not altogether escape the dangers of artificiality — Paladino's primitivism can seem a bit cooked up, especially in the sculptures which he produces in addition to his paintings. But he gives an effective new twist to the Italian tradition of respecting and studying, yet at the same time perverting the art of the past.

If one compares the Italian painters of the Trans-avantgarde to their German Neo-Expressionist counterparts, it becomes clear that the Italians lack complex political content, and concern themselves more with creating archetypes which can be seen as reflections of psychic states common to everyone, not just to men and women of one nationality. They are also much more interested in precise nuances of style, and have a greater tendency to stylistic pluralism.

BRITISH PAINTING

In the 1970s, it was British sculpture which seemed to attest to the continuing vitality of British art. By general consent, British painting had sunk into the doldrums after the excitement provided by the British Pop Art movement of the previous decade. Certain painters were ignored by critics because they seemed to have no place on the then current map of the various avant-garde movements and their relationships.

One artist marginalized by this pattern of thinking was Lucian Freud (b.1922). Freud, grandson of Sigmund Freud, the founder of psychoanalysis, was born in Berlin. His family emigrated to Britain in 1933 and Freud became a British citizen in 1939. His early work was in the Neo-Romantic idiom fashionable in Britain before and just after World War II. It was conspicuously brittle and mannered. During the 1950s his style began to change towards something broader and more painterly, and by the 1960s this stylistic change was complete. Important influences on him were Francis Bacon and the great seventeenth-century Dutch portraitist Frans Hals.

Most of Freud's mature pictures are portraits, or nudes with a portrait-like quality. Bacon taught Freud to look at the frequent lack of synchronicity between the bony armature and the envelope of flesh that covers it; Hals provided lessons in directness. As a result of his studying these artists, Freud's work acquired a deliberately raw quality. It was not technically Expressionist, but it had a similar psychological directness and disregard for social convention.

Throughout the 1960s and for most of the 1970s Freud's work seemed irrelevant to what was happening on either the purely British or the international scene. It did not change in any important respect in the 1980s, though at the beginning of the decade he did produce the largest and most ambitious canvas he had ever attempted – the *Large Interior W11 (After Watteau)*. The group of figures, drawn from his friends, is a paraphrase of Watteau's *Pierrot Content* in the Thyssen-Bornemisza collection in Lugano. They are, however, placed in the kind of sleazy studio interior familiar from a number of Freud's canvases, and not in the park-like open-air setting which Watteau provided in the original. The effect is strained, and Freud sensibly reverted to working on his more modest customary scale.

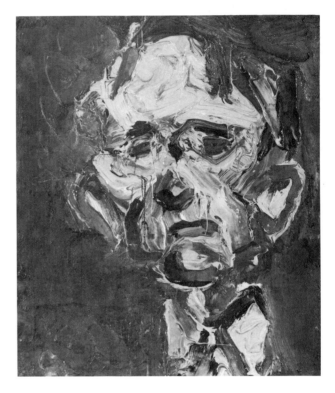

Frank Auerbach. *Head of J Y M.* **1987. Oil on canvas, 36.8 × 41.3 cm (14¹/₄ × 16¹/₄ in). Private Collection**

What did alter during the decade was the public reception of Freud's work. Its latent Expressionist qualities were recognized following the rise of Neo-Expressionism in Germany. At the same time, it could suddenly be seen that Freud's explorations were not entirely solitary even in England, but had things in common with the work of other British artists, particularly that of two pupils of David Bomberg – Frank Auerbach and Leon Kossoff.

Frank Auerbach (b.1931) is also a German Jewish refugee. He was sent to England as a child in 1939, and he lost his whole family in the Holocaust. Soon after World War II he came into contact with Bomberg and attended the classes which the latter taught at the Borough Polytechnic in London. Here he absorbed Bomberg's very personal variety of 'slow Expressionism', a way of painting best described as Expressionist brushwork allied to the painstaking exploration of external reality associated with Cézanne. From the beginning Auerbach was interested in searching for a true equivalence between the thing seen

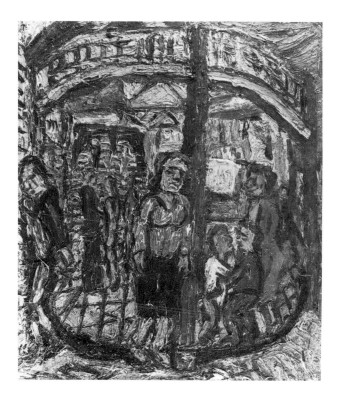

Leon Kossoff. *Outside the Booking Hall, Kilburn Underground.* 1980. Oil on board, 183 × 152.4 cm (72 × 60 in). Courtesy Fischer Fine Art Ltd, London

and the marks which appear on the painted surface. He wanted not merely to capture reality in paint but actually to re-create it on the canvas. He tackled the same narrow range of motifs with obsessive persistence – his usual subjects were heads and single figures (the same models sat for him patiently, year after year), and a few landscapes and cityscapes. In each work the paint was piled up in thick ropes and layers. The motif was depicted again and again on the same surface, partially scraped down between sessions, and then yet again repainted. Like Freud, Auerbach narrowed the range of his art so as to exclude all transcendental overtones. It was the painter's relationship to quotidian facts which counted.

Leon Kossoff (b. 1926) is Jewish too, but his family were Russian immigrants and had been settled in Britain for some time before the artist was born. He, too, became a pupil of Bomberg at the Borough Polytechnic, and his technique and attitudes are very close to Auerbach's, with perhaps a wider range of subject-matter and a greater latitude for the introduction of personal sentiment. Kossoff has painted many pictures of his father, for example (these correspond to a series of portraits of his mother painted by Freud).

At a first glance, Auerbach and Kossoff appear to be Expressionist painters; Freud, too, has at least a tenuous link to Expressionism. The fact that two of the three are of German origin may have helped to reinforce the idea that theirs is an art which offers parallels to the new movement in Germany. The stylistic similarities are largely coincidental. There is, however, one basic objective which the new Germans have in common with these much longer-established British artists: the search for a national identity.

Today, Freud, Auerbach and Kossoff produce work which is intimately connected with the painting produced in Britain in the opening years of the twentieth century. Through Bomberg, the latter two have a historical link with Vorticism. Their instinctive allegiance, however, is to the artists of the Camden Town Group, who clustered around Walter Richard Sickert (1860–1942), another foreign-born painter who made himself a consciously British persona.

One of the most significant exhibitions of the early 1980s, so far as younger British arts were concerned, was the *Late Sickert* show mounted by the Arts Council of Great Britain at the Hayward Gallery in 1981. The catalogue contains a foreword written by Auerbach in which he says:

If one were to ascribe a development to him, one might say that Sickert became less interested in composition, that is, in selection, arrangement and presentation, devoted himself more and more to a direct transformation of whatever came accidentally to hand and engaged his interest, and accepted the haphazard variety of his unprocessed subject-matter.

As it happens, this almost exactly characterizes the nature of Auerbach's own art, and applies fairly exactly, in addition, to Freud and Kossoff.

The formation of a new central group of senior artists tended to isolate others who might themselves have hoped to be part of the centre. However, one must except Francis Bacon (b. 1909) from this group, who has never aspired to centrality of any sort, and who, though attracting numerous imitators both in Britain and abroad (his work was particularly influential in Latin America after it was shown at the São Paulo Bienale), has never wanted to form a school. Bacon's painting, like Freud's, continued during the 1980s to follow a path which the artist had laid down for it a long time previously. The only scarcely discernible change was increased boldness of handling.

Howard Hodgkin (b. 1932) had been the odd-man-out amongst the artists of his generation in the days of Pop Art, and continued to be so now. Though his hermetic

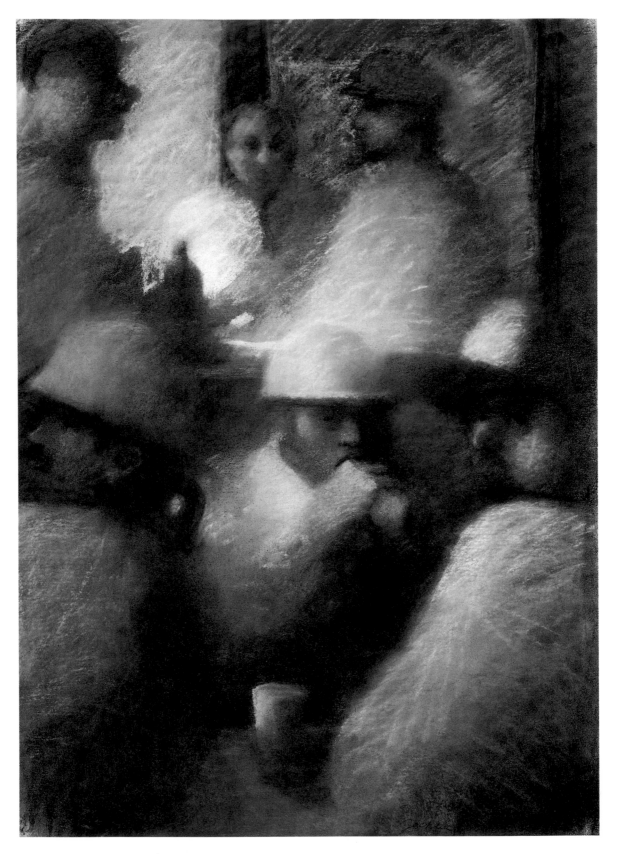

Bill Jacklin. *Franks.* **1988. Pastel on paper,**
105.4 × 75.5 cm (41¹/₂ × 29³/₄ in). Private Collection

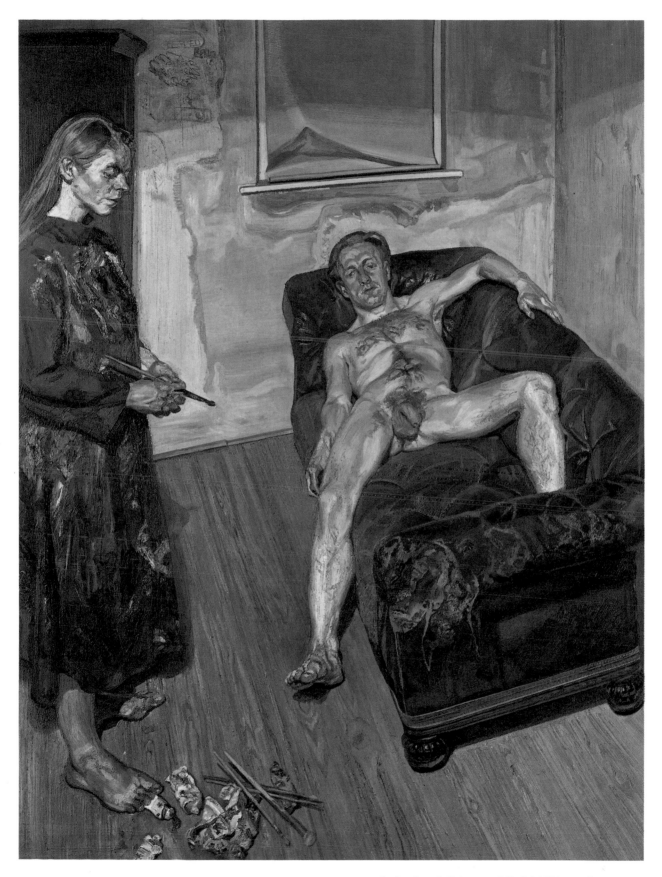

Lucian Freud. *Painter and Model.* **1986–7. Oil on canvas,
159.6 × 120.7 cm (65 × 47¹/₂ in). Private Collection**

Leon Kossoff. *Here Comes the Diesel*. 1987. Oil on board,
61.6 × 55.9 cm (24¹/₂ × 22 in). Courtesy Anthony d'Offay Gallery,
London

Frank Auerbach. *Head of Catherine Lampert.* **1986. Oil on canvas, 51.4 × 47 cm (20¹/₄ × 18¹/₂ in). Courtesy Marlborough Fine Art, London**

Howard Hodgkin. *Down in the Valley.* Oil on wood,
73.7 × 91.4 cm (29 × 36 in). Courtesy M. Knoedler & Co., New
York

compositions – memories of interiors with people in
them and of other scenes – had sometimes been loosely
described as Expressionist in the past, they did not fit the
Neo-Expressionist ethos because of their lack of rhetoric.
In the 1980s Hodgkin (always a slow worker) slightly
increased his production and the pictures became less
hermetic, with the figurative elements more clearly dis-
cernible. Reaction to his work was altered less by any
change in his approach or methods, than by a shift in pub-
lic taste (exactly as in Freud's case). What affected reac-
tions to Hodgkin's work was the rising interest in the
Bloomsbury Group. Attention had long been concen-
trated on Bloomsbury writers such as Virginia Woolf and
Lytton Strachey, but this now spilled over to include the
leading Bloomsbury artists Vanessa Bell and Duncan
Grant. As Bloomsbury's output in the visual arts became
better known and better understood, Hodgkin came to

seem more and more like a scion of the group, and in par-
ticular a descendant of the decorative painting done in
connection with the Omega Workshops. This, in turn,
tended to stress his fairly distant, but nevertheless very
real connection with Matisse.

Two highly successful younger painters also remained
in isolation. One of these was Bill Jacklin (b. 1943). Once
an abstract artist of crystalline elegance, he was now es-
tablished as a creator of complex figurative scenes. An
exhibition in the summer of 1988 at Marlborough Fine
Art, London, of Jacklin's recent work devoted to New
York cityscapes and interiors, showed that he has a con-
nection with some of the realists who had flourished in
New York during the 1930s, notably the twin brothers
Moses and Raphael Soyer. The realism practised by the
Soyers was always celebratory rather than critical – it did
not have the harsh edge of the work done by their New
York predecessors of the Ash Can School, or of that of
Sickert and the Camden Town Group. Jacklin is content
to celebrate what he sees in the same fashion.

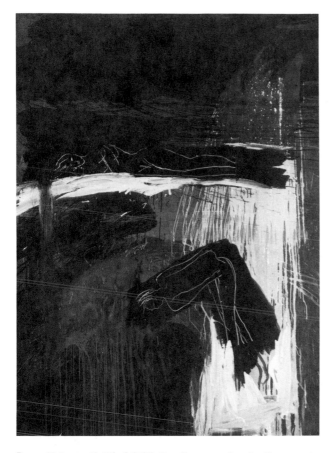

Bruce McLean. *Untitled*. 1986. Acrylic, enamel and collage on canvas, 281.9 × 200.7 cm (111 × 79 in). Courtesy Anthony d'Offay Gallery, London

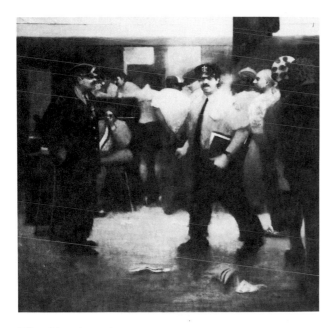

Bill Jacklin. *The Desk 35th Precinct*. 1988. Oil on canvas, 198.1 × 198.1 cm (78 × 78 in). Courtesy Marlborough Fine Art, London

Bruce McLean (b. 1944) came to the fore in the 1970s as a performance artist – one equipped with a sympathetic sense of irony. His painting developed out of the settings he created for his own performances. Though he is Glaswegian by birth, he has lived in London since 1963, and is not connected with the sudden blossoming of Scottish painting which occurred in the 1980s. When his paintings first appeared, they were immediately hailed as a development of Neo-Expressionism, on a par with what was being done in Germany, and they were vigorously marketed in New York on that basis. In fact, they seem to have little to do with any kind of Expressionism – they are full of bold gestures, decorative and theatrical, but they are not intense or filled with *Angst*. It is typical of the nature of McLean's talent that he has also successfully turned his hand to decorating pottery. His ceramics recall some of Picasso's best efforts in this field – they have the same wit, and the same terse economy.

Gilbert and George (b. 1943 & 1942) are also graduates of the performance art scene. They used to describe everything they produced as sculpture, and every action of their daily lives was meant to be regarded as sculpture too. In the 1980s their main effort went into the production of large photo-pieces. These are not paintings and should not be described as such, but they function in much the same way. Because of their explosive content, these photo-pieces have often aroused controversy. Some use religious imagery in a way which may seem blasphemous to believers; others contain erotic images, such as phalluses, or seem to celebrate neo-fascism. The stiffly polite and dignified demeanour of the artists has been an added irritant to their critics. The stringent discipline and unity of their style has obscured the fact that their work pulls in several different directions. Some of it seems to be the product of simple Warholian voyeurism; some is narcissistic self-celebration; some is filled with genuine social and moral indignation; some is deliberately provocative in the traditional fashion of avant-garde art. While it is a little difficult to decide on the aesthetic merits of what they do, there can be no doubt that it is an honest reflection of its time. The dislike it arouses should often be redirected to the surrounding political and economic circumstances – Gilbert and George merely show the spectator, with devastating clarity, what he knew existed

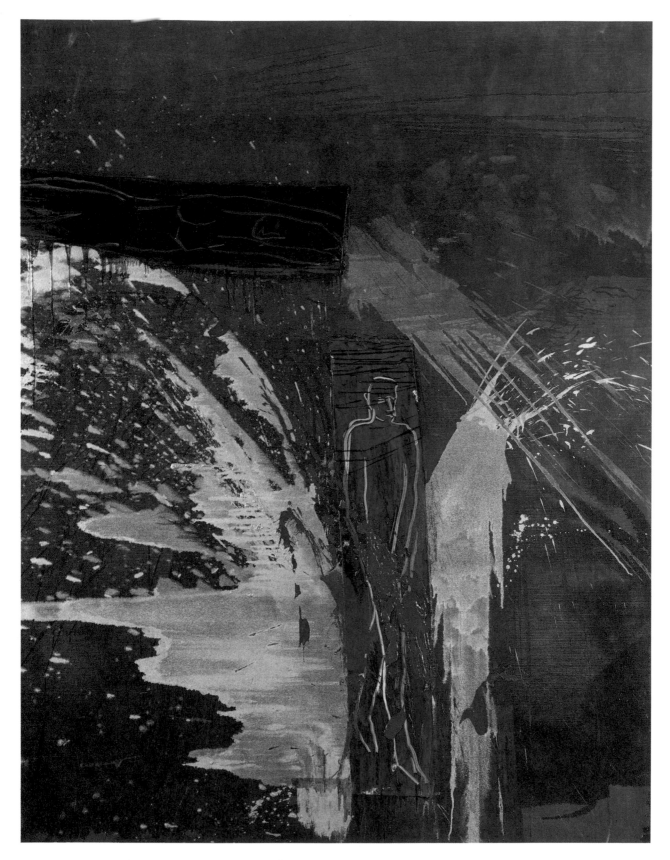

Bruce McLean. *Untitled.* 1986. Acrylic, collage and metallic paint on canvas, 260 × 198.5 cm (102¹/₂ × 78¹/₄ in). Courtesy Anthony d'Offay Gallery, London

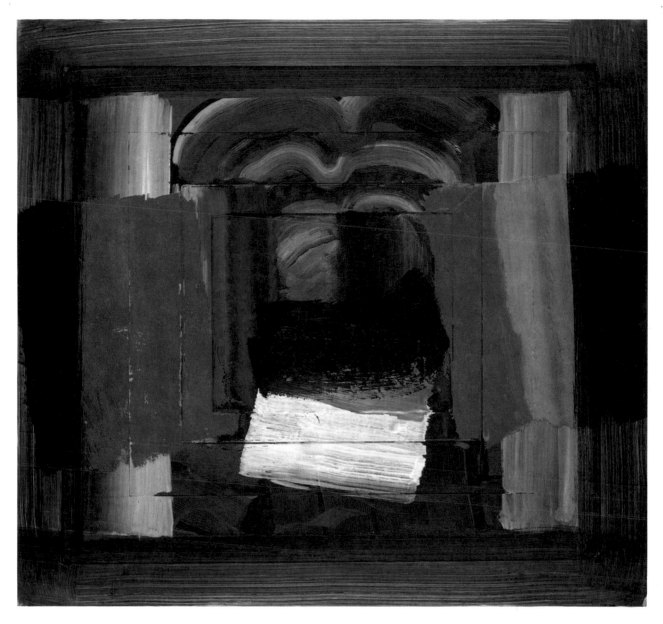

Howard Hodgkin. *On the Riviera.* 1987–8. Oil on board, 104.5 × 111.5 cm (41¹⁄₈ × 43⁷⁄₈ in). Courtesy M. Knoedler & Co., New York

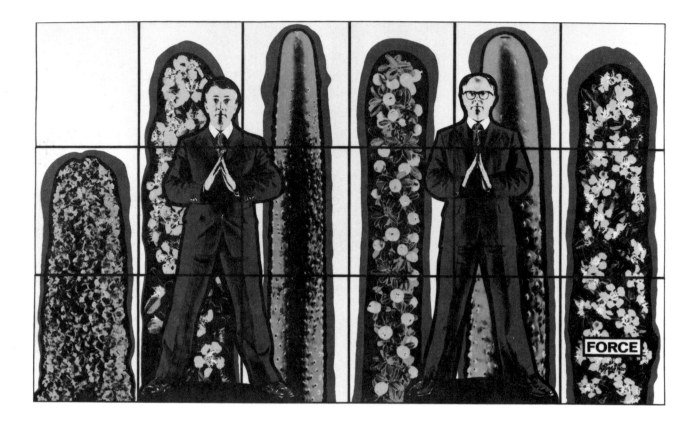

**Gilbert and George. *Force*. 1988. 27 × 381 cm (89¹/₄ × 150 in).
Courtesy Anthony d'Offay Gallery, London**

but had up to that moment managed to ignore. They have also shown particular sensitivity to contemporary issues – a faculty demonstrated by their Crusaid exhibition of 1989, when all the proceeds went to Aids charities. Gilbert and George are even more isolated stylistically than the other artists discussed in the second half of this chapter, but in the future they will almost certainly be seen as an important episode within the cultural history of the decade.

NEW SCOTTISH PAINTING

The loudest assertion of national identity to be made by younger British painters in the 1980s came not from England, but from Scotland. Throughout the twentieth century Scottish art has struggled to assert the fact that it has a different tradition from the English one, and therefore a separate personality. Between 1910 and 1930, for example, there was a powerful Post-Impressionist tendency in Scottish art. Among its chief representatives were S.J. Peploe (1871–1935), F.C.B. Cadell (1883–1937) and J.D. Fergusson (1874–1931). Peploe and Fergusson spent much time in France, and their work tends to be a direct response to French exemplars such as Cézanne and the Fauves (especially Matisse), without much reference to what was going on in England at the same moment. Until recently, the Scottish Colourists, as they are known, tended in turn to be ignored by the historians of British modernism. The show *British Art in the 20th Century*, mounted by the Royal Academy in 1987, not only omitted the Colourists but paid little attention to Scottish art in general. Those artists of Scottish birth who were included (a tiny handful) had long separated themselves from Scotland.

The current revival of interest in Scottish painting owes much to two artists who form a fascinating and instructive contrast. One is John Bellany (b. 1942). Bellany was born in the Scottish fishing village of Port Seton and attended the Edinburgh College of Art. In 1965 he moved to London, where he continued his training at the Royal College of Art, and since then he has based himself in the south, teaching until recently at various London art schools.

Throughout his career, however, Bellany has retained an ineradicable Scottishness. Much of his imagery relates to his childhood and youth. In dealing with it, he was able to turn to a native tradition of 'Scottish Expressionism', or at least of boldly brushed colouristic painting of a kind associated with artists such as William Gillies (1898–1973), William MacTaggart (b. 1903) and Joan Eardley (1921–63). The Expressionist impulse in Bellany's painting was focused and made more specific by his admiration for the work of German artist Max Beckmann (1884–1950), who is one of the important hidden influences in the art of the 1980s, not only in Germany, but internationally. In particular, Bellany was greatly

John Bellany. *Self-Portrait with Juliet*. 1981. Oil on canvas, 172.7 × 152.4 cm (68 × 60 in). Private Collection

influenced by Beckmann's triptychs, with their mysterious and fantastic imagery, to such an extent he quite often adopted the triptych format himself.

Bellany's work was featured in quite a number of mixed exhibitions held in Britain during the 1970s. It is symptomatic that he was selected for an Arts Council Touring Exhibition entitled *Scottish Realism* in 1971, and for another called *Scottish Expressionism* in 1977. The difference in titles does indicate a stylistic shift in Bellany's work, but is far more indicative of the change of artistic climate which was taking place in Britain during the decade. Bellany was, however, surprisingly slow to make an international breakthrough. His first solo exhibition in New York did not take place until 1982, and the venue was a little-known private gallery. He is, in consequence, less celebrated than the German Neo-Expressionists who are his exact contemporaries, and whose work in many respects resembles his. He is also less fêted than Scottish painters substantially younger than himself.

John Bellany. *The Quack*. **1988. Oil on canvas,**
182.8 × 243.8 cm (72 × 96 in). Courtesy Fischer Fine Art Ltd,
London

Steven Campbell. *Three Men of Exactly the Same Size in an Unequal Room*. 1987.
Oil on canvas, 249 × 277 cm (98 × 109 in). Collection: Leeds City Art Gallery.
Courtesy Marlborough Fine Art, London

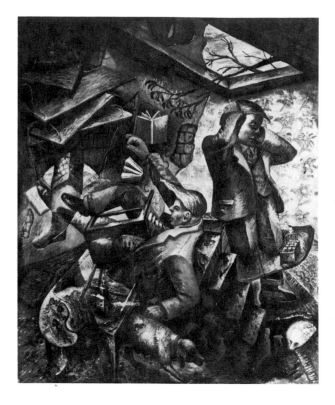

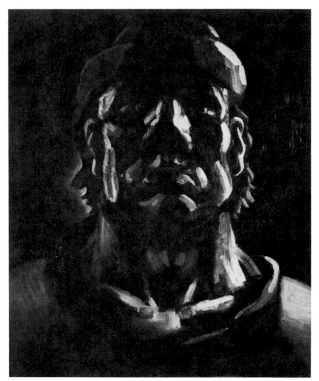

Steven Campbell. *'Twas once an Architect's Office in Wee Nook.* 1984. Oil on canvas, 292 × 241 cm (115 × 95 in). Collection Bette Ziegler, New York

Peter Howson. *Self-Portrait.* 1987. Oil on canvas, 105 × 89 cm (41.1/2 × 35 in). Courtesy Flowers East, London

Peter Howson. *The Psycho Squad.* 1989. Oil on canvas, 214 × 274.5 cm (84 1/4 × 108 in). Courtesy Flowers East, London

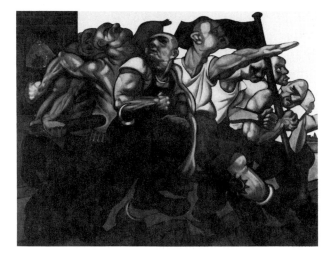

The other artist who played a key role in the emergence of a new Scottish scene is Steven Campbell (b. 1953). Campbell's background is significantly different from Bellany's. He spent seven years as a fitter in a steelworks, then attended Glasgow College of Art, which is still housed in the magnificent and aggressive Art Nouveau building designed for it by Charles Rennie Mackintosh (1868–1928). Instead of making his way to London when he graduated, Campbell migrated across the Atlantic, and he lived and worked for five years in the United States. His first solo exhibition was with the well-respected Barbara Toll Gallery in New York's SoHo, and he had another show the same year at the John Weber Gallery. By the end of 1986 he had had exhibitions in Chicago, Munich, Minneapolis, Washington DC, Berlin, Geneva and San Francisco, as well as in London and Edinburgh – a good example of the rapid international exposure now available to successful young artists.

Campbell's work is much less Expressionist than that of Bellany. Both the drawing and the actual handling of paint have a lot in common with that of German artists like Peter Chevalier and Thomas Schindler, who are his exact contemporaries. However, Campbell's compositions tend to be both more capricious and more complex. Campbell begins with a single image, then develops the picture through a process of free association. The poses and gestures of his figures are deliberately conventionalized: whatever is shown is presented with humorous irony. Nevertheless Campbell, having so firmly ignored England and English institutions when planning his career strategy, remains obsessed with English (not Scottish) culture. Gainsborough and the writer P.G. Wodehouse both play an important part in his quirky personal mythology. His stocky figures are dressed in the

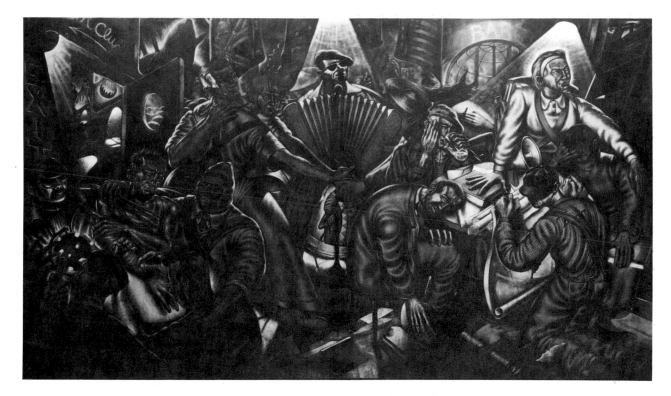

Ken Currie. *In the City Bar*. 1987. Oil on canvas,
210.8 × 370.8 cm (83 × 146 in). Collection Susan Kasen and
Robert D. Summer, New York

tweedy outfits of England in the 1930s, and inhabit the
facetious yet slightly sinister universe of W.H. Auden's
early poetic charade, *Paid On Both Sides*. The comparison
with Auden is suggestive – Campbell remains helplessly
attached to a world which in theory he dislikes and
condemns, which was precisely Auden's situation.

The work of the two artists with whom Campbell is
most closely associated, Peter Howson (b.1958) and Ken
Currie (b.1960), seems straightforward in comparison.
Howson, though recognized as a leading member of the
new Scottish school, was in fact born in London and
moved to Scotland when he was a child. His training at
the Glasgow School of Art was broken by a period when
he dropped out and did various odd jobs, including a stint
in the British army. This seems to have had a lasting effect
on Howson's imagination, since he tends to depict an
exaggeratedly masculine world, often one with sado-
masochistic overtones. His most impressive pictures
show not thuggish soldiers or boxers (though these also
feature largely) but Glasgow down-and-outs, who are
presented as heroic yet powerless, tragic rejects of capital-
ist society who have found reserves of stoic courage with
which to resist their fate.

Currie began as a student of social sciences before going
to art school. When he began to paint, he was at first a
disciple of the Scottish Colourist tradition, but soon

rejected this in favour of work with a strong narrative con-
tent. Currie's artistic exemplars are impeccably left-wing
– among them are Otto Dix and Max Beckmann (though
he rejects the fantastic side of the latter), Fernand Léger in
his pro-Communist and post-Cubist phase, and the Mex-
ican Muralist Diego Rivera. More and more he has tended
to make his work a mythologization of Glasgow itself.
One sequence of large drawings Currie describes as 'a
flickering black and white newsreel of class struggle on
the Clyde in the twentieth century, seen through the eyes
of a man who has been at the sharp end of the struggle all
of his life.'

Currie's large compositions, technically very accom-
plished, are amongst the most convincing things of their
type to have been produced in the 1980s. He shows real
control over big spaces and the ability to orchestrate many
figures and their accoutrements into an intricate and co-
herent whole. What is perhaps more questionable is the
relationship between his art, its contemporary setting,
and the ideology he professes. Currie says that he has the
desire to find a new and less doctrinaire equivalent for
Soviet and Eastern European Socialist Realism, but puts
this idea forward at a time when Socialist Realism itself is
in the process of being totally rejected in its countries of
origin. He works in a city which has recently become cele-
brated, not for continuing dereliction, but for a dramatic
economic and cultural revival. His commitment to
Socialist Realism seems nostalgic in view of the changes
now taking place both in Britain and abroad.

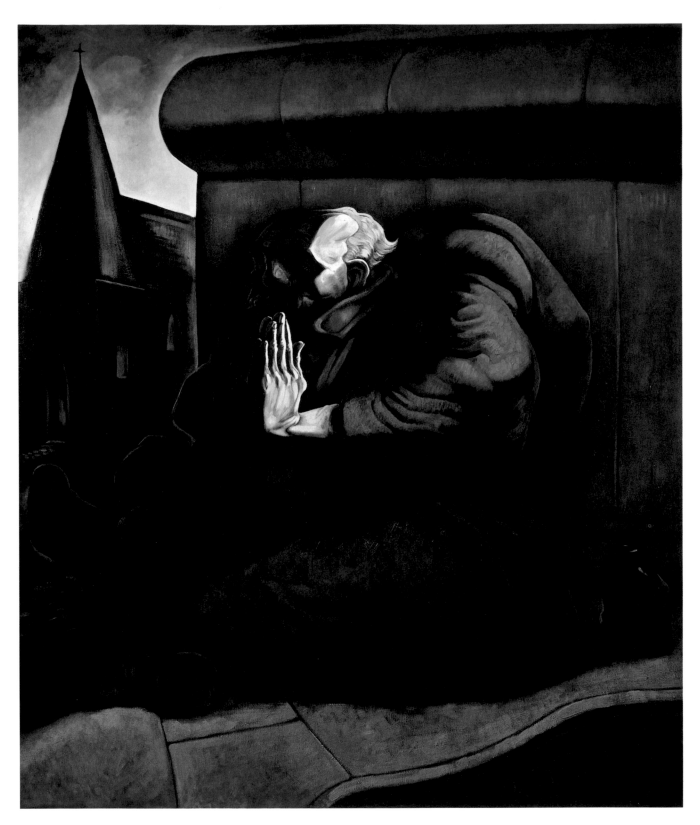

Peter Howson. *A Wing and a Prayer*. 1987. Oil on canvas,
244 × 213 cm (96 × 83³/₄ in). Courtesy Flowers East, London

Ken Currie. *Departure*. 1987. Oil on canvas, 213 × 366 cm
(84 × 144 in). Courtesy Raab Galleries, Berlin/London

NEW ENGLISH PAINTING

English painting in the 1980s has been considerably more romantic in tone than its Scottish equivalent, less stylistically coherent, and without the same orientation towards political and social issues. Two of the most successful artists have been Christopher Le Brun (b. 1951) and Ian McKeever (b. 1946). Le Brun came to prominence in 1979 as a prize-winner in the biennial John Moores Exhibition held in Liverpool, and held his first one-man exhibition in London in 1980. Since then his work has been widely shown internationally.

Christopher Le Brun. *Grove*. 1987. Oil on canvas, 106.7 × 266.6 cm (90 × 105 in). Courtesy Nigel Greenwood Gallery, London

Le Brun's original influences, when he was still a student, were the American Abstract Expressionists, for example the earlier work of Philip Guston. But by the beginning of the 1980s he had begun to paint mythological landscapes, thus returning to what some critics think of as a primary source for Abstract Expressionism – the work of J.M.W. Turner. Le Brun himself seems to have been attracted by the canvases where Turner comes closest to the Symbolist movement – for example, *The Angel Standing in the Sun*, shown at the Royal Academy in 1846. Critics have also detected resemblances between Le Brun's work and that of Arnold Böcklin and Gustave Moreau. Many of the paintings produced in the first half of the 1980s feature superb horses, often winged, so perhaps

one should also point to a possible connection with de Chirico, who during the inter-war period produced a long series of compositions showing horses on the beach. Le Brun's work is unashamedly full of references to classical and medieval literature – to the heroes of Ancient Greece and Rome, and to Sir Bedevere, Sir Tristram and the other members of King Arthur's Round Table. This subject-matter and Le Brun's nostalgic opulence of style supply two good reasons for his popularity with collectors on both sides of the Atlantic.

Much tougher, and owing more to the Conceptual Art of the 1970s, are the landscape paintings of Ian McKeever, who is somewhat older than Le Brun but has been slower to win international acclaim. His approach to landscape is through photography – blown-up photographs fragmented and collaged on to canvas, a technique also used on some occasions by Anselm Kiefer. The scenes McKeever prefers are wild and desolate, and over the years his treatment of the photographic source material, which he overpaints and now almost completely conceals, has become increasingly stormy and dramatic. Of all the painters in England now using landscape imagery, he is perhaps the most powerful.

Another Turner disciple, but one who approaches this source from a completely different angle, is Thérèse Oulton (b. 1953). Oulton produces paintings which look landscape-like in the finished result but do not seem to use landscape as a direct source. The composition grows sequentially from the marks the artist puts on the canvas – that is, one mark suggests another, without reference to objective reality. What seems to be an influence here is Turner's handling of paint, rather than his subject-matter.

Andrzej Jackowski (b. 1947) represents an image-based approach, perhaps more definitely so than any of the three painters mentioned so far. He therefore stands for a different aspect of the new English romanticism. Jackowski was born in Wales but his parents were Polish, and he spoke almost nothing but Polish until he was seven years old. He thus, like Lucian Freud in an earlier generation, retains elements of the outsider, in the sense that he has emotional access to a culture other than the native one. Jackowski's early training was at the Camberwell School of Art during the 1960s, and was strictly in the English

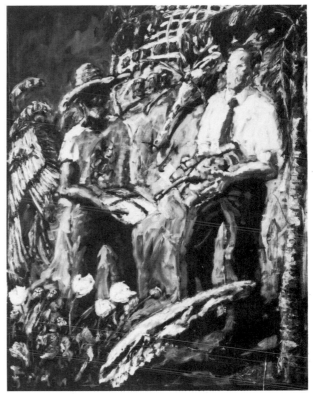

Andrzej Jackowski. *Bride/The Hatching Ground*. 1988. Oil on canvas, 152.5 × 142 cm (60 × 56 in). Collection Contemporary Art Society. Courtesy Marlborough Fine Art, London

John Keane. *The Exchange*. 1985. Oil on canvas, 211 × 168 cm (83 × 66 in). Courtesy Angela Flowers Gallery, London

realist tradition. When Jackowski moved from London to Cornwall to study at the Falmouth School of Art, he came into contact with the poet Peter Redgrove, and this had a liberating effect on his work, putting him on the path to the kind of symbolic figuration he now uses.

The painter-critic Timothy Hyman, in a conversation with Jackowski which is printed as the preface to the catalogue of the latter's 1989 exhibition at the Marlborough Gallery, London, notes that the events in Jackowski's paintings seem to take place 'in a time before or after or *outside* our civilization'. Jackowski corrects him by suggesting that his work is a kind of 'archaic fiction'. Certainly his paintings usually seem to deal with mysterious legendary events.

One recent influence which Jackowski himself notes in his own work is that of de Chirico's one-time comrade in the *Pittura Metafisica* movement in Italy, Carlo Carrà (1881–1966). The consistently dark, glowing tonality of Jackowski's paintings, and his frequent use of images of large, looming heads, also bear likeness to certain paintings by a more recent Italian artist, Enzo Cucchi. This illustrates how Jackowski's work is Expressionist as well as Symbolist. It is significant, for example, that he was included in a touring show entitled *The Subjective Eye*, which travelled to a number of British galleries in 1981–2, and which was perhaps the first attempt to identify the new Expressionist current insofar as it affected British art. Even today, Jackowski seems to be one of the British painters who comes closest to the aims and ideas of continental Neo-Expressionism.

John Keane (b. 1954) has a different relationship to Expressionism from that which appears in Jackowski's work, and a far more superficial one. What links him to aspects of Expressionism is the lively painterliness of his handling – he is a most attractive user of paint as a material, and his paintings are also notable for their freshness of colour and for the skill with which Keane manages to incorporate various collage elements, such as pieces of newspaper, without compromising the integrity of the picture surface. These skills are put to the service of a talent for ironic reportage. A recent series of paintings devoted to the theme of Nicaragua (which Keane visited in order to paint them) was very far from the kind of propaganda painting which subjects of this kind usually evoke from Neo-Expressionist artists.

The new British school of the 1980s produced a number of gifted women artists, in addition to Thérèse Oulton. This is a significant phenomenon in a country which has usually been somewhat hostile to women's creativity in the visual arts, if not in literature. Two of

Ian McKeever. *Through the Ice Lens*. 1986. Oil and photograph on canvas, 200 × 170 cm (86³/₄ × 66³/₄ in). Courtesy Nigel Greenwood Gallery, London

Thérèse Oulton. *Viscous Circle*. 1989. Oil on canvas,
228.6 × 182.9 cm (90 × 72 in). Private Collection. Courtesy
Marlborough Fine Art, London

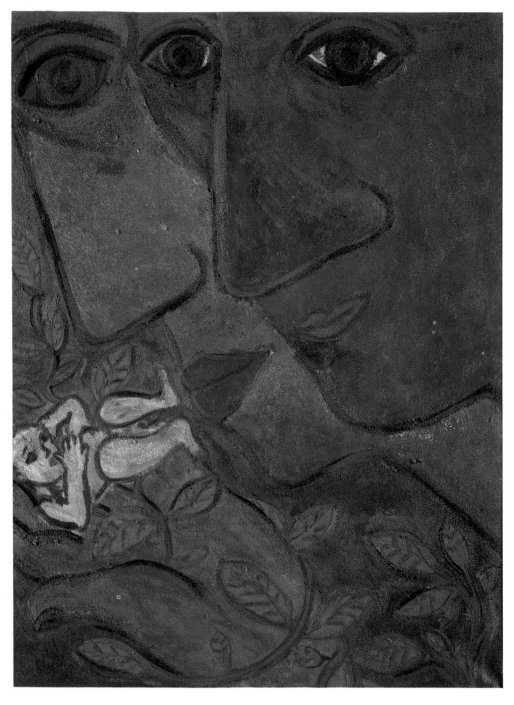

Eileen Cooper. *Baby Talk.* **1985. Oil on canvas, 121.9 × 91.4 cm
(48 × 36 in). Courtesy Benjamin Rhodes Gallery, London**

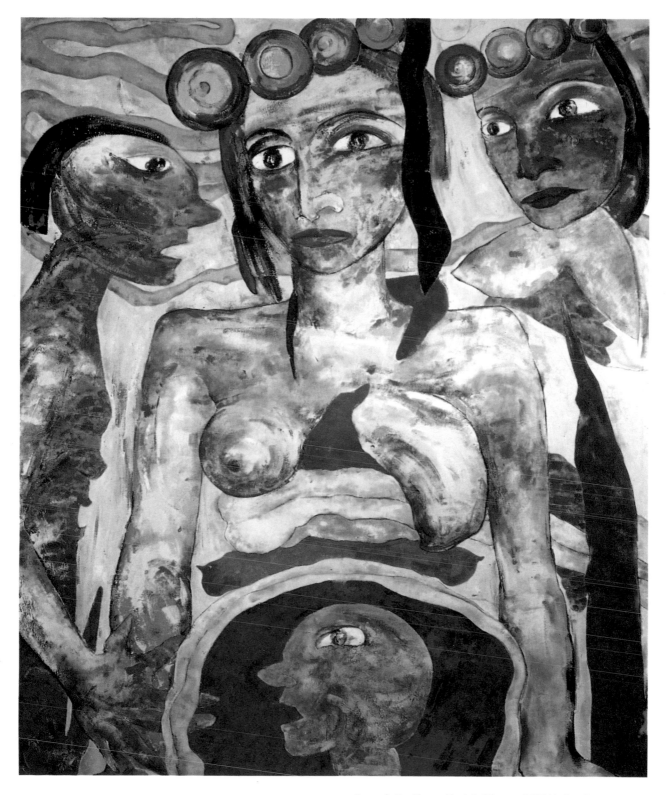

Amanda Faulkner. *Upright Woman*. 1985/6. Acrylic on canvas,
183 × 153 cm (72 × 60¼ in). Courtesy Angela Flowers Gallery,
London

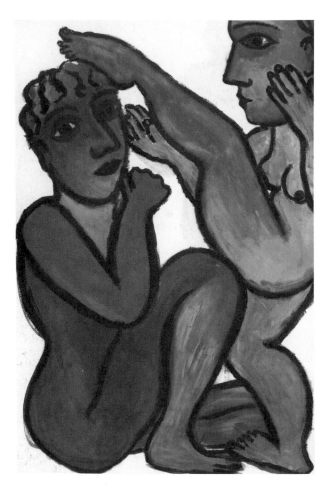

Eileen Cooper. *Last Tango*. 1988. Acrylic on paper, 120 × 80 cm (47¹/₂ × 31¹/₂ in). Courtesy Benjamin Rhodes Gallery, London

John Kirby. *Family Ties*. 1988. Oil on canvas, 204.5 × 158.8 cm (80¹/₂ × 62¹/₂ in). Courtesy Flowers East, London

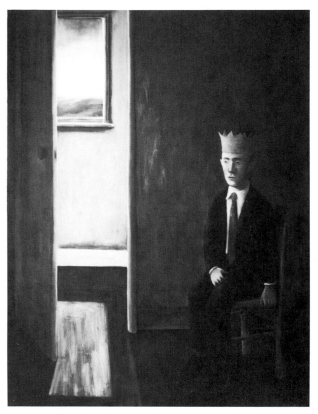

these artists are Eileen Cooper (b. 1953) and Amanda Faulkner (b. 1953). Both make work which is consistently bolder in style than that of most of their male colleagues. Cooper's art is largely autobiographical, concerned with topics such as the birth of her children. She makes use of personal events as the starting point in her search for universal female archetypes. Amanda Faulkner works in a very similar vein. One of her frequent themes is the idea of the double – of two opposing or conflicting selves. She also explores other aspects of duality, such as love of yet hostility towards children.

Towards the end of the 1980s, British painting seemed to be moving away from its predominantly romantic-expressionist idiom. Two examples of this shift are John Kirby (b. 1949) and Ansel Krut (b. 1959). When compared with other British painters who are their contemporaries, both come from unusual backgrounds. Kirby was a late starter in art. A Liverpool Catholic, he worked for a period as assistant director of Boys Town, Calcutta, and later as a probation officer in south London. His paintings, which have a strong plasticity but which are fairly tight in technique, have links to those produced by *Neue Sachlichkeit* artists in Weimar Germany. Neverthe-

less, and despite the artist's background in social work, they have no trace of political content but are instead deeply and introvertedly personal. Most of them explore what Kirby speaks of as the two chief formative influences on his life: his Catholic upbringing and problems of sexual identity. Many are self-portraits (one might say, more accurately, self-representations). One typical example shows an older self keeping company with a younger one. Others show a figure who can be identified as the artist wearing women's clothes. These strange and disturbing paintings are amongst the most memorable to have been produced in Britain in recent years.

Ansel Krut was born in South Africa and studied at the University of the Witwatersrand in Johannesburg. He then lived and worked in Paris before coming to London to study at the Royal College of Art. His work, often small in scale, shows the influence of the more fantastic side of Goya, and perhaps also that of the American Jules Pascin, (1885–1930). Many of Krut's paintings are

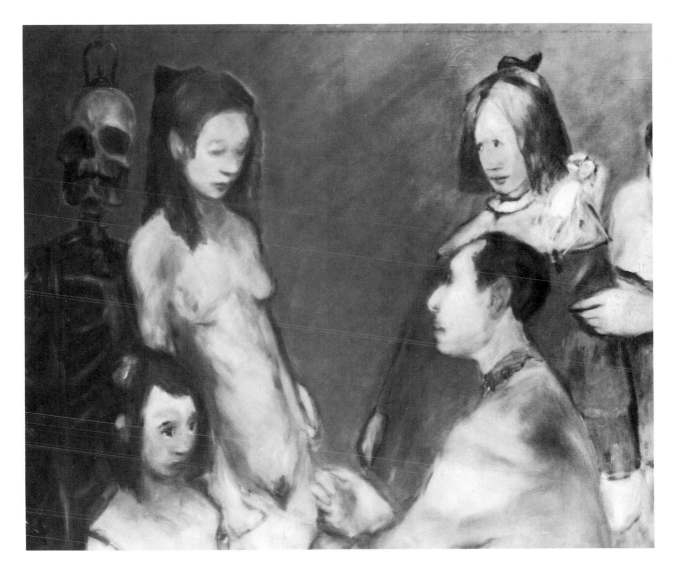

Ansel Krut. *The Student of Philosophies*. 1988. Oil on linen, 100 × 120 cm (39³/₈ × 47¹/₄ in). Courtesy Fischer Fine Art, London

extremely erotic, with undertones as disturbing as those to be found in the work of John Kirby. A series produced in 1988 shows an adolescent girl, nude, melancholy and passive to the point of torpor, being man handled by an older man or men. The suggestion is often that she is being treated as a ventriloquist's dummy. These images are exquisitely painted. Krut uses a tightly controlled range of subdued tones, the flesh slightly ashen, the backgrounds greenish-grey or rosy grey. Like Kirby's, his paintings stick in the memory and find a disturbing place there.

AMERICAN EQUIVALENTS FOR NEO-EXPRESSIONISM

It is now generally recognized that art in the United States underwent important changes in the 1980s. The exact nature of these changes is not so widely agreed. It seems to me that the only way in which we can understand the most recent American painting and sculpture is by comparing it both to the art of Europe, and to the art which provides its background in America itself. A brief historical summary is therefore required.

In the 1940s, Abstract Expressionism with the work of Pollock, de Kooning, Rothko and others established the international dominance of the New York school. Though it owed much to European Surrealism, and especially to the 'gestural' or 'calligraphic' wing of Surrealist painting (André Masson, Joan Miró and Matta), Abstract Expressionism pushed things much further than Surrealism had ever dared to do. In particular, it took the idea of automatism, and applied it to the creation of paintings rather than works of literature.

Certain aspects of Abstract Expressionism were soon recognized as having a specific relationship to American life in the 1940s and 1950s. In tune with the prosperity which now prevailed in the United States, it explicitly rejected the social concerns which had preoccupied the immediately previous generation of American artists, and reverted to the nineteenth-century concept of a 'frontier' which could be pushed forward without respite into unknown territory. This frontier, however, was psychological rather than geographical. Abstract Expressionist theory emphasized complete freedom of expression, and it was the artist's duty to record the uncensored motions of his own psyche. Each painting was seen as the product of a creative personality standing completely alone. The relevance of Abstract Expressionist attitudes to the individualism characteristic of American society was perhaps more clearly recognized by European critics than American ones.

The dominance of New York was not threatened when Abstract Expressionism was challenged by newer styles. In fact, these styles made New York more rather than less important as a point of reference. Some of the material they used came from the life of the city itself, and, like Abstract Expressionism, they depended on New York galleries, public and private, for initial exposure and subsequent validation. The most significant of these successor styles were the Neo-Dada of Robert Rauschenberg and Jasper Johns, and the American variety of Pop Art.

The new generation of American artists, in contrast to their predecessors, featured specifically American images in their work. Johns used the American flag and the map of the United States for some of his most acclaimed early paintings. The Pop artists were fascinated by the icons of American mass culture: comic-strips, images of film stars, products like Coca-Cola and Campbell's soup. Much of what they did had a close relationship to American advertising; some Pop painters, such as Warhol and Rosenquist, actually began their careers working in the advertising industry. However, though Pop referred to the social context, it was careful not to criticize it. It was celebratory or, at the least, neutral. The sole, and striking, exceptions, were Warhol's *Disaster* paintings.

During the 1970s, New York was more successful than ever as a market-place for contemporary art, and transactions became increasingly international. Within the United States, collecting the latest art was now a prestigious activity, and new artists found eager customers. As the impetus behind Pop Art faded, a number of younger artists began to concentrate on something which had always been implicit within it — an investigation of the nature of imagery, and thus, by implication, of the nature of art itself. Art-about-art took many forms, but much was Conceptual or Minimalist. As a result, the flourishing commercial impulse just described was confronted with a product whose chief qualities were often puritan reticence and stringency.

In these circumstances it is not surprising that the work of the German Neo-Expressionists and the Italian Trans-avantgarde met a warm welcome in New York. The return to conventional formats and the greater variety of content were alike greeted with relief. The one difficulty was that this flood of imports from Europe seemed to threaten the American hegemony which most of the New York art world still took for granted. It is not surprising that certain American artists were soon singled out as representatives of the new movement. One was Julian Schnabel (b.1951). He was one of only two American Neo-Expressionists to be selected for inclusion in the Royal Academy's *A New Spirit in Painting*.

The identification with Neo-Expressionism was ac-

cepted without demur at the time, not only by commentators but by the artist himself. Today, however, Schnabel's likeness to the new European art seems a lot less obvious. For example, there is a great difference in attitude towards concepts such as nationality and rootedness, both so important in Europe. There is no doubt that Schnabel feels himself to be specifically American, just as Anselm Kiefer feels himself to be specifically German. But the two artists explore these parallel identifications in different ways. Kiefer tries to find a perspective which will enable him to define and comment upon German cultural and political history. Schnabel's historical and cultural attitudes are less complicated. They are well described by Richard Francis in his catalogue preface for the Schnabel exhibition held at the Tate Gallery in 1982:

His predilection for literature for instance is for the 'wild men': he cites Artaud, Bukowski, Cesar Vallejo and most recently the convicted murderer Jack Henry Abbott. All these men have audacity; they are positively anti-bourgeois and display their rebellion and suffering openly.

Schnabel's own anti-bourgeois credentials are doubtful in the extreme, not least because of his quest for and obvious pleasure in material success. But, while his political, social and literary attitudes are unsophisticated, his purely artistic ones are not. His work shows an intimate knowledge of the way in which American art has developed since the heroic days of Abstract Expressionism, and contains an eclectic mixture of different American styles. Some of his paintings are done on a surface made up of pieces of broken crockery, a device which seems to owe a good deal to the work of the Filipino-American artist Alfonso Ossorio (b. 1916), who has married aspects of Abstract Expressionism to things learned from Jean Dubuffet. Schnabel's handling of paint on this difficult support often shows a dexterity worthy of John Singer Sargent, and, when using it, he has increasingly veered towards Sargent in his choice of subject-matter. Many of his recent paintings are the late twentieth-century equivalent of Edwardian society portraits: glamorous images of self-evidently fashionable sitters.

Other paintings by Schnabel are quite different technically. Many are under the spell of Rauschenberg at his most Dadaist. One typical series, produced in 1988, consists of small eighteenth-century engravings collaged onto large canvases, which have been splashed with a few large areas of paint then decorated with the graffito 'La banana é buona'. Schnabel is usually criticized for technical crudity and for trying to be avant-garde at all costs. In fact, his work shows much technical calculation, even where it lacks obvious refinement. It is full of aesthetic ploys which only the initiated will recognize. His deployment of technique is precisely the aspect of his art which does give evidence of considerable cultural sophistication. Unlike European Neo-Expressionism, which often tries to make a political point to a presumably popular audience, Schnabel is content to address the cognoscenti. What he produces is a twisted or altered version of what has gone before which depends heavily on the spectator's knowledge of the original source. It is thus typical of scholarly art throughout the ages – the second phase of Italian Mannerism, for instance.

Very much the same comments can be made about another much-praised artist of Schnabel's generation, David Salle (b. 1952). In a press release put out for an exhibition of Salle's work held at the end of 1982, his paintings were described as being 'redolent of that fridge-raiding, corner-cutting, head-shrinking, violent, messy, clean, sexually obsessed, verbally articulate, quintessentially youthful society' which is still to be found in the United States. Anonymous blurb-writers are not really to be blamed for this kind of rhetoric, and the description does seem apposite in one respect: it paints a clear verbal picture of the kind of thing which many American Pop artists were doing in the 1960s, and suggests Salle's close kinship with them. In his case, the model often seems to be James Rosenquist (b. 1933), whose use of multiple images reappears in Salle's work, often with a graffito-like obbligato or overlay.

Three other American artists have been seen as having affinities with the Neo-Expressionist movement. One is the English-born Malcolm Morley (b. 1931), who is considerably older than either Salle or Schnabel. Morley began as one of the pioneers of Photo-realism, in the 1960s, and in the 1970s gradually developed a much more painterly type of handling. By 1981, when he was selected for *A New Spirit in Painting*, this handling did seem to have some Expressionist characteristics. In fact,

Julian Schnabel. *You Must be Intimate with a Token Few.* **Oil on canvas, 243.8 × 152.4 cm (96 × 60 in). Courtesy The Pace Gallery, New York**

David Salle. *An Illustrator Was There.* **1981. Acrylic on canvas, 213.2 × 152.5 cm (84 × 60 in). Private Collection**

Malcolm Morley. *Farewell to Crete.* **1984. Oil on canvas, 203.2 × 416.6 cm (80 × 164 in). Saatchi Collection, London**

his new work taken as a whole often seems closer to Surrealism than to Expressionism. The pictures are often conjunctions of incongruous images, rather than logically and spatially coherent compositions, and many of these images, in turn, are painted from toys – a procedure which stresses both the triviality of the enterprise and the savage sarcasm of the result. Morley seems to be a man who profoundly distrusts art, who is often seized by doubts as to whether or not it is a truly serious activity in the context provided by American society. He is obviously hostile to the lionization which is now the lot of the successful artist. And he, like Schnabel, is essentially a Mannerist; he recycles and comments upon the creative ideas of earlier generations of modernists.

Susan Rothenberg (b. 1945) has reacted to the strains imposed on the artist by contemporary society in a somewhat different way. Unlike Morley, her work is not derived from Pop, with additional borrowings from earlier styles such as Dada, Surrealism, Abstract Expressionism and Neo-Dada. Instead her earlier work was marked by a retreat into a kind of primitivism which suggests a desire to identify with the very earliest artists –

those who produced the cave paintings of Palaeolithic times. The horse paintings which established her reputation in the 1970s were at first very close to Palaeolithic art in style. Since then Rothenberg has gone on to paint bones, body parts, humanoid figures and, finally, landscapes. In all these enterprises there still seems to be a search for some primitive essence of experience.

Susan Rothenberg. *Night Ride.* **1987. Oil on canvas, 236.2 × 280 cm (93 × 110¹/4 in). Courtesy Sperone Westwater Gallery, New York**

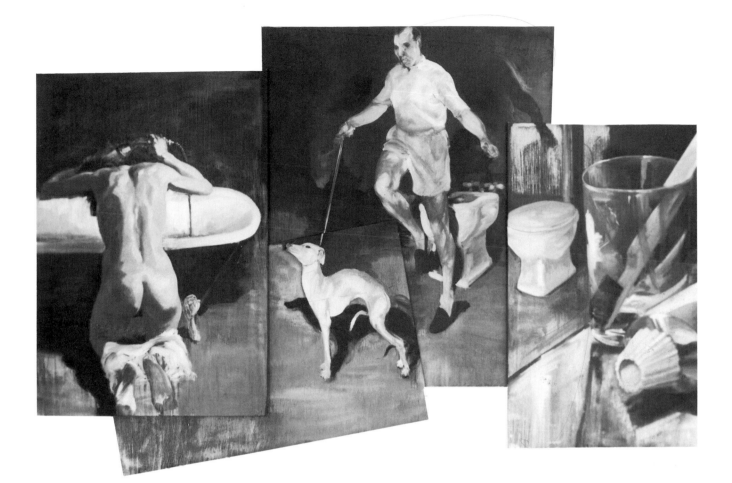

Eric Fischl. *Portrait of a Dog.* **1987. Oil on linen, 285.7 × 433.7 (112¹/₂ × 170³/₄ in). Courtesy Mary Boone Gallery, New York**

Eric Fischl. *Help.* **1980. Oil on canvas, 152.4 × 243.8 cm (60 × 96 in). Courtesy Nigel Greenwood Gallery, London**

Very different is the work of a major new star of the 1980s, Eric Fischl (b.1948). Fischl's reputation, unlike that of either Morley or Rothenberg, belongs wholly to the decade. He held his first one-man show in 1980, at the Edward Thorp Gallery in New York. Since that time he has been widely shown in both the United States and in Europe, and his work has aroused a great babel of commentaries. In a sense, this is not surprising, since commentary is exactly what the paintings invite. They are interrupted narratives, or, in the words of Frederic Tuten, who wrote the catalogue preface for Fischl's 1989 exhibition at the Waddington Galleries, London:

Fischl is a painter of fictions incomplete: no openings and closures: all middles... His is the *mise en scène* of psychic turbulence located in what are otherwise considered the centres of the conventional and the normative, the comfortable preserves staked out by the middle class.

Adjectives which have been applied to Fischl by other critics, but without any especially pejorative overtones, are 'sleazy' and 'voyeuristic'.

With Fischl, more than with most artists, one must split the analysis of his work into two aspects – what he

shows, and the means he uses to show it. What he shows is, as Tuten suggests, scenes from the life of the prosperous middle class: on the beach, in the street, in the garden, in the living-room, in the bedroom. Many, but not all, of the incidents he depicts are concerned with sexuality, adolescent sexuality in particular. Fischl himself once said that the central theme in his work was:

…the feeling of awkwardness and self-consciousness that one experiences in the face of profound emotional events in one's life. Those experiences, such as death, or loss, or sexuality, cannot be supported by a life style that has sought so arduously to deny their meaningfulness, and a culture whose fabric is so worn out that its public rituals and attendant symbols do not make for adequate clothing… Each new event is a crisis, and each crisis …fills us with much the same anxiety that we feel when, in a dream, we find ourselves naked in public.

These themes, with their direct references to the condition of contemporary American society, do make Fischl in some ways the equivalent of his German Neo-Expressionist contemporaries. His technique, however, less bold and painterly than theirs, often borders on the fumbling. The notion has been put forward that Fischl's pictures succeed precisely because they teeter on the brink of technical incompetence.

Fischl himself has remarked in an interview: 'I'm still ambivalent towards skill, I'm afraid. I want it and I also want to throw it out.' In various forms, this ambivalence has been typical of much of the American art of the 1980s, and it calls into question claims that American pre-eminence in the visual arts must continue for the foreseeable future. In blunt terms, 'New York style', in its latest manifestations, shows signs of having lost its nerve.

GRAFFITI PAINTING AND RELATED STYLES

The style most closely identified with New York during the first half of the 1980s was Graffiti Painting. It was also one of the shortest-lived art phenomena of the decade. Graffiti artists were, at first glance, related to Pop. Their work could certainly be seen as yet another manifestation of Pop culture. Nevertheless there were important differences between these artists and their predecessors in the 1960s. Almost without exception the leading Pop artists were art-school trained. Their attitude towards mass culture was knowing, distanced and essentially judgemental. The overlay of 'cool', of assumed emotional neutrality towards what was depicted, signalled their separation from their source material.

This separation did not exist in the case of the Graffiti painters. They began their careers as working-class adolescents without formal art training. They were the leaders of a New York teen and pre-teen craze for adding unofficial decorations to public sites and, in particular, to the trains which ran on the city's subway system. What they did sprang directly from the popular urban culture of the city, without reference to modern art or art movements such as Dada. They played a competitive game amongst themselves. Defiance of adult authority was demonstrated by their ability to put their names or pseudonyms on view in as many public places as possible.

These 'tags' or signatures became increasingly bold and decorative, and identifiable styles of lettering developed, often linked to particular boroughs, such as Brooklyn. By the early 1970s ambitious Graffitists were decorating whole subway cars with their designs, and a war of words had broken out between the city authorities and those who defended Graffiti as a new and exciting manifestation of the creative spirit of New York. The first exhibition of Graffiti art — subway decorations transferred to canvas — took place in 1973. By the late 1970s Graffiti Painting had become a staple of the gallery scene which had sprung up on New York's Lower East Side — a symbol of opposition to what was being shown in the established galleries in SoHo and on 57th Street. It proved to be so much talked about and so commercially successful that it soon made the transition to more established venues. The Sidney Janis Gallery, which had been one of the chief promoters of Abstract Expressionism, began to represent a number of young Graffitists.

Graffiti Painting, unlike earlier American avant-garde styles, did not make the breakthrough to international renown. Outside New York it tended to be regarded as an ethnographical curiosity, on a par with Eskimo prints or Zimbabwean stone carvings. Like these 'transitional' art works, it suffered from the disadvantage of being produced by one social group for consumption by another, whose attitudes and values were totally different. As they moved further from their own teen years, and as the graffiti craze itself died away (a decline helped along by vigorous repression on the part of the city transport authority), the work of the Graffiti painters became increasingly tired and repetitive.

The one artist associated with the Graffiti Painting movement who seemed capable of establishing himself internationally was Jean-Michel Basquiat (1960–88). The son of a Haitian father and a Puerto Rican mother, Basquiat had a rebellious early career in the New York public school system and was duly drawn into the graffiti cult, adopting the name 'Samo', which stood for the phrase 'same old shit'. He was different from his fellow-Graffitists in several respects: he came from a background which was at least on the fringes of the middle class; he had considerable intellectual curiosity (one series of his paintings was based on drawings by Leonardo da Vinci); and he also had a notable graphic gift. His abilities won him early recognition, and he progressed through a series of dealers in New York, producing a large quantity of work and generating considerable sums of money for himself and his promoters. It is an indication of Basquiat's facility, and also of the kind of art world he moved in, that some of his exhibitions seem to have been painted to order, just before the opening, in concentrated bursts of work.

Basquiat was almost the only artist connected with Graffiti Painting to make a substantial individual reputation outside the United States, showing in Switzerland, West Germany and Italy; and he was established very early in the secondary market, with paintings selling well at auction only two or three years after they were produced. He attracted the attention of Andy Warhol, who showed his usual keen eye for anything that was at the forefront of fashion and innovation. Warhol and Basquiat eventually produced a series of collaborative works.

Jean-Michel Basquiat. *Untitled.* **1984. Acrylic and mixed media
on canvas, 167.6 × 152.4 cm (66 × 60 in). Private Collection**

Kenny Scharf. *Untitled-Elroys.* **1981. Acrylic on plastic,
147.5 × 152.5 cm (58 1/8 × 60 in). Private Collection**

Keith Haring. *Untitled.* **1983. Ink and gouache on paper,
109 × 79 cm (42⁷/₈ × 31¹/₈ in). Private Collection**

Warhol's bland images, with their close kinship to
billboard imagery, provided a good starting point for
Basquiat's improvisations. The younger artist, however,
did not have the equable temperament needed to survive
success and, like some of the performers who starred in
Warhol's underground movies of the late 1960s, he
became drug-dependent and died of an overdose at the age
of twenty-eight.

More peripherally connected to Graffiti Painting than
Basquiat, but linked to it for a moment, was Keith Har-
ing (b. 1958). Haring played no part in the New York
teen-scene which spawned the original graffiti craze, and
he did not, in fact, come to live in the city until he was
already twenty. He studied at the School for Visual Arts,
where one of his teachers was the well-known Conceptual
artist Joseph Kosuth. Taking art into the streets was a

Conceptual gesture. In 1980 Haring began to make drawings in the subways, using the empty black panels where advertisements were due to make their appearance. The black background and the material Haring used on it – chalk, the quickest and cheapest means of drawing available – led him to evolve a large, uniform vocabulary of graphic signs quite unlike the playful, wilful style of home-grown New York Graffitists. When Haring began to work in a less ephemeral way, this vocabulary proved adaptable to almost any surface, from the traditional artist's canvas to T-shirts. For a while Haring became one of the symbolic figures in the East Village art scene. Adaptability in one sense meant a certain inflexibility in another. Oil paint or acrylics never seemed to be Haring's essential, primary means of expression. His graphic language was not truly painterly, and this, indeed, was the reason why it could be used successfully on so many different surfaces, employing a wide variety of media. It now seems likely that Haring will be classified not as an important painter who continued to develop once the 1980s were over, but as a striking period piece.

Kenny Scharf (b.1958) was at one time closely associated with Haring. They shared a loft together; and Scharf, too, was a moving spirit in the galleries of the East Village which had sprung up to challenge those in more established commercial locations. Scharf was never truly a Graffitist, though he likes to add wild decorations to ordinary objects, such as radios, in addition to painting in a more conventional way on canvas. He really represents a baroque variant of the old Pop spirit – a revival of Pop Art concerns within the rather different cultural context of the 1980s. The adjective 'baroque' aptly describes the exuberance of Scharf's imagery, but it is also fair, in a different sense, to describe his work as 'Mannerist' – it represents an intensely self-conscious return to artistic concerns which were once treated more innocently and straightforwardly. One can think of Pop or popular art as having several stages. First, there was a completely unselfconscious mass culture which matured during the

Kenny Scharf. *Decisions*. 1988. Oil on canvas, 68.7 × 53.4 cm (27 × 21 in). Courtesy Tony Shafrazi Gallery

1940s and 1950s. Then in the 1960s the work of the original Pop artists removed the innocence of many mass-cultural manifestations which had up to that point been accepted, without either thought or comment, as a 'given' within the American urban scene. Scharf treats not the original source material, such as advertisements and comic-strips, but the work of the first wave of Pop artists of the sixties as the 'given' element. He recognizes it as an inescapable part of his own intellectual context, and he plays ever wilder variations based on these sources. His work cannot have its full impact unless the audience is aware of to what it alludes.

THREE PHOTOGRAPHERS

One significant comment on the condition of painting and sculpture in New York during the 1980s may be offered by noting the success of photography. As a means of creative expression, this rose to a position of pre-eminence it had never previously enjoyed. Two factors contributed to this success. One was the link between the camera and the Conceptual Art of the late 1960s and 1970s. The other was the increased attention paid to the aesthetics of the medium, and especially the factors which distinguished these from the aesthetic theories prevailing elsewhere. The pioneering study in this field was Susan Sontag's dazzling essay *On Photography*, first published in 1972. Photography's rise in status was also apparent in the booming market in old photographs, once an almost totally neglected area of collecting.

The most prominent of the new generation of American photographers was Robert Mapplethorpe (1946–89), whose prestige was confirmed by a full-scale retrospective held in 1988 at the Whitney Museum of American Art. Mapplethorpe's work, and its critical and public acclaim, represent an extraordinary conjunction of social and cultural influences.

Before he won recognition as a photographer Mapplethorpe had enjoyed minor local celebrity status as the star of a notorious underground movie, *Robert Having his Nipple Pierced*, and also as a maker of collages, often highly erotic in content. Much of his earliest photographic work, done in the mid and late 1970s, is a documentation of sado-masochistic homosexuality. These bizarre and, to many people, shocking and frightening images were presented with great visual formality and also with a kind of mocking insolence which made them seem the essence of New York 'cool'. To everyone who looked at these pictures Mapplethorpe seemed to say: 'Are you going to lose your nerve over this? After all, this is *art* – and in contemporary art, how far is too far?' It is not surprising that these early photographs achieved an immediate, if limited, success. What is perhaps astonishing is the ease with which Mapplethorpe transcended his specialized beginnings, and became a charismatic mainstream figure.

Most of his work falls into a small number of categories. There are role-playing self-portraits (in make-up, for example, or in leather); there are nudes, the majority of which are males, many of them black men; there are portraits which feature either celebrated creative artists or people who belong 'to a small, consciously fashionable segment of New York society on the fringes of the art world (being photographed by Mapplethorpe became as much of an accolade, in its own way, as being painted by Warhol); finally, there are austerely disciplined studies of flowers. The majority of the images are in black and white.

Robert Mapplethorpe. *Rose with Smoke*. 1985. Platinum print, 58.4 × 49.5 cm (23 × 19¹/₂ in). Copyright © 1985 The Estate of Robert Mapplethorpe

Mapplethorpe's work shows a number of significant influences. It is clear, for instance, that he had a wide-ranging knowledge of the photography of the past. The photographers who made an impact on him cover a wide spectrum, but their work is invariably extremely disciplined, not spontaneous. His influences included the turn-of-the-century pictorialists – Baron de Meyer's flower studies and his pictures of the dancer Vaslav Nijinsky seem to have had a special appeal. One can also see that Mapplethorpe had looked at the work of Man Ray and Frantisek Driskol; at the leading fashion photographers of the 1930s and 1940s; and, perhaps most closely

Robert Mapplethorpe. *Thomas in a Circle*. 1987.
Platinum on linen canvas, 66.1 × 66.1 cm (26 × 26 in).
Copyright © 1987 The Estate of Robert Mapplethorpe

of all, at the male nudes of George Platt Lynes. The result is photographs which are a unique amalgam of the challenging and the wholly accessible.

The deliberate, almost hostile elegance of Mapplethorpe's work makes a striking contrast with most New York painting and sculpture, and it was not until the appearance of the cast stainless-steel sculptures of Jeff Koons that it found a partial equivalent. The core of Mapplethorpe's art is the series of studies of black men. The nudes have a glacial formality; they suggest that the photographer is quite indifferent to the personality of the sitter – often, even in full-length studies, the face is not shown. A number of photographs concentrate on body-parts – a torso, an arm, even a penis. The coldness intensifies the erotic charge.

Mapplethorpe's work succeeds, and retains its avantgarde credentials despite its accessibility, because it touches upon so many difficult issues and subverts so many cherished assumptions. It is in many ways nostalgic, but it shows no sign of nervousness or apology for this. Its racial attitudes are questionable – Mapplethorpe treats his blacks as beautiful animals, not as fellow human beings. The kind of sexuality he celebrates has now acquired an even more dubious overtone than it possessed previously, following the appearance of the Aids epidemic; and Gay Liberation, with whose wilder fringes Mapplethorpe's early work was often identified, is everywhere in retreat. Despite all of these negative factors, Mapplethorpe's work has not only been immensely successful within the New York milieu, to which in any case it owes so much, but it has also been a major cultural export and has appeared in museum shows all over the world. He is now one of the most widely exhibited of contemporary New York artists.

Two other New York-identified photographers of some importance are Bruce Weber (b. 1946) and Cindy Sherman (b. 1945). Weber, like Mapplethorpe, celebrates the male body. As with Mapplethorpe, there is a strong element of the nostalgic in what he does; he too seems to owe something to George Platt Lynes; and he too is in thrall to the 1930s. His portraits of American athletes, produced in the run-up to the Los Angeles Olympics of 1984, are reminiscent of some of the images in Leni Riefenstahl's famous film of the Berlin Olympics of 1936. Weber is

more journalistic than Mapplethorpe – he has done work for Warhol's *Interview* magazine and a good deal of fashion photography. Compared with Mapplethorpe, he usually looks rather timid and sentimental. He is a gifted creator of images, extremely responsive to the cultural climate of his times, rather than someone truly authoritative.

Cindy Sherman's reputation is based on large Cibachrome photographs ($72 \times 47^{1}/_2$ inches is a not uncommon size), nearly all of which are self-portraits. The roles she adopts are so various and her use of make-up and disguise so proficient, that it is often difficult to recognize that these are all likenesses of the same individual. In Volume IV of *Art of Our Time* (the catalogue of part of the immense Saatchi Collection), Mark Rosenthal remarks that:

Formally, Sherman's photographs have more to do with the history of painting than that of photography. She often employs mannerist or baroque lighting effects and compositions, and her love of textural play and detail reflects an attention to surface and detail such as might be found in a work by Velázquez or Matisse. Even her concentration on the subject of women is in keeping with the history of painting.

A lot of awkward questions could be asked about this encomium. For example, are Velázquez and Matisse really notable for their love of detail? Has photography in general been indifferent to the subject of women? The really significant thing, however, is the effort to separate

Cindy Sherman. *Untitled*. 1985. Colour photograph, 152.4 × 101.6 cm (60 × 40 in). Courtesy Metro Pictures, New York

Sherman's work from the rest of photography and turn it into something which is quite different in kind. The futility of the effort is demonstrated by something Rosenthal says only a couple of paragraphs later:

… the photographs possess the spirit of the 1940s and 1950s. Yet, although each appears familiar, as if taken directly from a well-known movie, television drama or advertisement, it is a product of Sherman's subtle absorption and adaptation of these sources.

The general drift of this is clear: Sherman's roots are in the photography of the immediate past and in its offshoots in the cinema and in television. The weak spots in her work are not only its rather humourless self-absorption but also its pretentiousness. One suspects that the claim to be different *in kind* from the rest of contemporary photography must emanate finally from the artist herself. Her nervousness about the status of the medium she uses does her no credit.

Sherman's work seems to be the termination of a long process covering three decades. First, the discovery and exploration of mass culture associated with the Pop Art of the 1960s; then the Conceptual formation of major issues (in this case personal identity and feminism) typical of much art in the 1970s; and finally the return to the photographic medium as a thing in itself, and not just as the humble tool which it remained for both Pop and Conceptual artists, who were happy to use the camera but resistant to the idea that it had any special qualities of its own.

POST-GRAFFITI ART IN NEW YORK

It was natural that the New York art scene should make a more serious effort to reassert its international pre-eminence than could be effected through supporting the Graffiti painters. The art which came to prominence during the second half of the 1980s had a more conventional background – the artists were middle-class and from art school. It was also highly conscious of its own heritage – its roots in the immediate past of American art, and in the history of modernism in general. It owed a good deal to Pop, something to Dada and Neo-Dada, and also much to various aspects of the Conceptual Art which had flourished in the late 1960s and the 1970s.

This new art made a number of assumptions which could not have been made with such confidence in any other milieu – for example, that there was already a large and steady audience for all avant-garde manifestations in the arts; and that this audience was thoroughly versed in the history of modernism from the 1940s onwards, and

attuned to the debate about the nature of visual representation begun by Roy Lichtenstein's comic-strip translations of earlier modernist styles such as Cubism, and continued by Photo-Realist imitations of photography. Unlike the European audience, however, this New York equivalent was largely apolitical. The politics it was most passionate about were those of the art world, a cosmos which it thought of as possessing an existence quite independent of and separate from the rest of America.

One result of these preoccupations and assumptions was a return to abstraction. New York art was thus sharply opposed to what was taking place in Europe, or even in most of the rest of the United States. Examples of this new interest in abstraction were the work of Philip Taaffe (b. 1955), Peter Schuyff (b. 1956) and Peter Halley (b. 1953). Taaffe parodied aspects of 1960s Op Art; Schuyff moved to a version of Op from a version of the Biomorphic Surrealism (Arp, Tanguy, etc.) popular in

Peter Schuyff. *The Weld*. 1985. Acrylic on linen, 304.8 × 304.8 cm (120 × 120 in). Saatchi Collection, London

Philip Taaffe. *Untitled*. 1984. Linoprint, collage, acrylic on paper, 189 × 150 cm (74³/₄ × 98³/₄ in). Saatchi Collection, London

the 1930s; while Halley, whose work seemed to owe more than a little to that of Josef Albers, took a nostalgic look at the sensibility of the Bauhaus.

Of the three artists just named, it is Halley who currently seems the most interesting. One reason for this is that his work, in addition to having roots in the history of modernism, is equally firmly rooted in the ecology of New York, and in particular owes much to its characteristic architecture – itself the ultimate, corrupted product of the success achieved by leading Bauhaus architects during their years of American exile, from the mid-1930s onwards. Like many of the New York artists of his own generation, Halley is articulate. He says, for example, that he wanted to alter the meanings usually attached to the square, a form which is a basic signifier in certain forms of modern art:

I felt I could use the square as an example of how to take these

meanings and change them into other meanings. I wanted to change the square as being abstract and purely unrelated to the world, and posit it as having some kind of physical reality in the world. I wanted to take the idea of rationality as being something positive and re-examine it as either being negative, or at least worth examining as something other than positive. Finally, the square is one of those geometric forms we think of as an ahistorical, a priori mental structure – and I wanted to look at it as an historical structure that has had specific historical uses.

Halley adds to this:

One of the initial motivations in my work is that when I first came to New York, I was so fascinated by facades and decoration. If you went into an office building everything was covered with marble, or wood panelling, or what have you. And I was fascinated by the idea that the conduits, the supportive structure, was always hidden. I thought to some extent this was a

Haim Steinbach. *No Wires, No Power Cord.* **1986. Mixed media construction, 73.7 × 118 × 47cm (29 × 46¹/₂ × 18¹/₂ in). Courtesy Sonnabend Gallery, New York**

Philip Taaffe. *Banded Enclosure.* 1988. Mixed media on canvas,
345.4 × 396.2 cm (136 × 156 in). Courtesy Pat Hearn Gallery,
New York

Peter Schuyff. *Untitled.* **1988. Acrylic on linen, 190.5 × 190.5 cm
75 × 75 in). Courtesy Pat Hearn Gallery, New York**

characteristic of contemporary society, and of capitalism in general. I aspired to actually ferret out and bring forward some of those structural conditions that exist behind the facades, if you will.

This is in fact one of the few examples that I know of a directly political comment emanating from an artist of this group. It would be very difficult to deduce any kind of political content from Halley's paintings taken in isolation.

It is clear, however, that this generation of New York artists remains fascinated in a more general sense by the consumer society, whose beneficiaries they are; and that their relationship to it is even more ambiguous than that of the American Pop artists of the 1960s. Most of the Pop artists transformed consumer images when they put them to use. An outstanding example of this process of transformation is the soft sculpture of Claes Oldenburg – giant versions of electric egg-beaters made of vinyl stuffed with kapok, and allowed to hang and loll in shapes which are visceral and phallic rather than hard and mechanical like the original objects.

Andy Warhol was the one leading Pop artist who did not transform consumer objects but took pains to imitate them exactly, in an early series of cartoons for Brillo soap pads. Warhol is the direct ancestor of a whole series of three-dimensional works recently made in New York. Examples are the vacuum cleaners in plexiglass cases 'made' by Jeff Koons (b. 1955), and the baskets, sneakers, footballs and other objects on plinths presented by Haim Steinbach (b. 1944). But these works differ from Warhol's boxes because the main components are not imitations – they are things selected from the surrounding environment in the same way that Marcel Duchamp once chose his now-classic found objects – the *Bottlerack* and the *Fountain* (which was in fact a urinal). All that separates Koons and Steinbach from Duchamp is a nuance. Duchamp's objects were intended as a mockery of the high-art pretensions of his contemporaries – avant-gardists even more than academic artists. In the case of these successors it is not certain that any mockery is intended. If so, the target may well be Duchamp himself, whose most potently rebellious ideas have been so effortlessly absorbed and recycled *ad nauseam* by members of the post-World War II mainstream.

If any one member of the New York avant-garde has succeeded in producing a totem artwork – something which sums up the sensibility of a particular group of artists at a particular moment – this achievement must be attributed to Koons. The work in question is in some ways atypical of his production. *Rabbit 1986* is a sculpture made in cast stainless steel. The 'original' on which this sculpture is based is a novelty balloon, whose soft distended forms have been reproduced exactly in this most recalcitrant of materials. The piece belongs to a whole series of sculptures by Koons which use the same medium. All reproduce pre-existing objects, from a cheap reproduction of an eighteenth-century bust to a novelty decanter for bourbon whisky in the shape of a toy train. All have obvious qualities in common. They are cold and hard; they look consciously chic and expensive despite their flauntingly tacky source material. It is probable that they can all be read as doubly or even triply sarcastic – the victims of this sarcasm being those who consume, i.e. buy, the original objects; those who consume them in the same fashion when they are transformed into high-priced art; and the artist himself, who mocks his own traditional function, which is to re-create reality.

Rabbit 1986 has more impact than the rest of the series both because the shift from one material to another is so extreme and because the simple distended forms of the blown-up balloon suggest a comparison with certain 'classic modern' sculptures – most obviously sculptures in polished metal by Hans Arp, which similarly combine hardness, shininess and apparent squashiness.

By making works of such different kinds within a very short time span, Koons demonstrates an eclecticism which has become an issue in much of the art produced in the 1980s. One of the most dedicated pluralists is another New York artist, Ross Bleckner (b. 1949). Bleckner says:

If I feel honest about making the paintings I make, I also have to allow for certain kinds of mutations within who I think I am. It's how you really speak in a layered way, and how you really are polyvocal. I think that there's a certain kind of confusion or ambivalence in just how and what it is we are emotionally and psychologically, that exists in us all, always, but is never really seen as a possibility, is always seen as a limitation instead. Because I think that, so often, painters see something as having, or refining, a certain set vision. And I don't see myself as having a set vision. I see myself as a human being involved in a kind of productive activity which is almost like the transparent nature of thinking.

Bleckner mimes these 'mutations', as he calls them, in paintings which often seem to shift between genres. Some of his works, like Taaffe's, look like parodies of the Op Art of the 1960s, or of the Post-Painterly Abstraction which flourished at the same epoch. However, a canvas filled with narrow vertical stripes will also sport what looks like a *trompe l'oeil* ribbon rosette, stuck at random on the surface, in complete contradiction to the rest of the design. Other paintings strike a transcendental note, with chalices surrounded by rays or transparent starry globes against a mysterious dark background like a night sky. It is difficult to tell how these apparently solemn images are meant to be taken, when the artist himself

Ross Bleckner. *One Day Fever.* **1986. Oil on linen, 121.9 × 101.6 cm (48 × 40 in). Courtesy Mary Boone Gallery, New York**

declares: 'I take all the work that I look at as seriously as I take making my own work, which is only half-seriously. There's a real sincerity and a fake sincerity that have to play off each other simultaneously. I've always said that I'm trying to find the sublime by de-mystifying it.'

Bleckner's work lacks the cold arrogance which emanates from some of what is now being made in New York. But it does suffer from a whimsicality and a trickiness which have also come to seem characteristic of the 'New York style' of the late 1980s. Whether the city can retain the artistic pre-eminence established nearly fifty years ago, on the basis provided by this latest generation of artists, must now be anyone's guess.

Peter Halley. *Red Cell.* 1988–9. Acrylic and roll-a-tex on canvas,
221 × 259.1 cm (87 × 102 in). Courtesy Sonnabend Gallery,
New York

Ross Bleckner. *Examined Life.* **1988. Oil on canvas,
243.8 × 182.9 cm (96 × 72 in). Saatchi Collection, London**

AMERICAN ART OUTSIDE NEW YORK

Perhaps the most striking thing about the American art of the 1980s was its increasing tendency towards regionalism. This became ever more manifest despite fierce resistance from critics who continued to base themselves in New York, and the equally New York-based publications they wrote for. The identification of particular art styles with particular areas of America was not in itself new. It first manifested itself in the 1930s, with the movement which was indeed called Regionalism. In the 1960s there was a fresh assertion of regional identity, in the Midwest and in California. In Chicago it coincided with the emergence of various groups of new artists, among them the Hairy Who (1966), the False Image (1968) and the Non-Plussed Scene (1968). Generally these groups have been described as a local variant of New York Pop Art, but the reality was more complex than this.

The new Chicago style had diverse roots. It sprang from European Surrealism. (Surrealist art of the inter-war period is splendidly represented in Chicago's public and private collections.) It sprang from the *art brut* of Jean Dubuffet (shown in Chicago in 1951) and the 'social protest' paintings of Leon Golub. It also sprang from the work of certain local 'outsider' artists, notably the untrained black artist Joseph Yoakum (1886–1976), who spent a good part of his life travelling restlessly as a circus employee or a hobo, and who only began to paint in 1962.

Surrealist and 'outsider' influences are prominent in the work of leading Chicago painters such as Jim Nutt (b. 1938) and Gladys Nilsson (b. 1940), while Ed Paschke (b. 1939) and Roger Brown (b. 1941) show strong traces of influence from the kind of material which also interested New York Pop painters, such as television and comic-strips, but they use these sources in a very different way from Lichtenstein, Rosenquist or Warhol. Chicago art had no ambition to be 'cool'. As Roger Brown says in a statement written for the 'Who Chicago' exhibition which toured British venues in 1980–1:

One of the distinct qualities of the artist in this movement is an intensity, a kind of religious fervor towards their visual concerns as opposed to a merely political fervor which I perceive among artists of different persuasions. Sometimes I think art is really much closer to religion than politics.

Roger Brown. *Chicago Taking a Beating.* 1989. Oil on canvas, 121.9 × 182.9 cm (48 × 72 in). Private Collection

Gladys Nilsson. *Forewarned.* 1986. Watercolour, 152.4 × 102.4 cm (60 × 40¹/₄ in). Courtesy Phyllis Kind Gallery, New York

Joseph Yoakum. *Sweeden Valley in Allegheny Mountain Range near Harrisburg, Pennsylvania.* 1968. Pastel on paper, 30.5 × 48.3 cm (12 × 19 in). Private Collection

This 'fervor' may serve to explain why Chicago art already, as early as the late 1960s, paralleled some aspects of the European Neo-Expressionism then struggling to be born.

The artists of Brown's generation enjoyed such an overwhelming success locally that it was perhaps difficult for younger figurative artists working in the same vein to establish themselves in Chicago itself. However, the Hairy Who style was rapidly disseminated to other regions with which the Midwest had historic, economic or cultural connections. It rooted itself in Texas and it travelled down the Mississippi to Louisiana.

In Texas, Peter Saul (b. 1934) shows the same mixture of Pop and Surrealist elements as that which appears in the work of Nutt and Nilsson, while the mixture of comic strip and 'outsider' influences is visible in the painting of David Bates (b. 1952). Saul and Bates, though a generation apart, have one characteristic in common, which perhaps serves to distinguish them from their equivalents in the Midwest. Both are very much narrative artists, and this interest in narrative – in the tall tale well told – can be seen as one of the leading characteristics of Texan art. Landscape painters working in Texas also tend to use stylizations which derive from the art of the Chicago School.

David Bates. *Blue Norther.* 1988. Oil on canvas, 182.9 × 152.4 cm (72 × 60 in). Courtesy Charles Cowles Gallery, New York

Jim Nutt. *Loop.* 1988. Acrylic on canvas, 65.3 × 60.2 cm
(25^5/$_8$ × 23^5/$_8$ in). **Private Collection**

Craig Antrim. *Ravages of Faith*. 1988. Wax, oil, charcoal and acrylic on canvas, 60.9 × 45.7 cm (24 × 18 in). **Private Collection**

Gary Washmon. *Isolation*. 1983. Acrylic on canvas, 182.5 × 243.5 cm (72 × 96 in). Courtesy Frumkin and Struve Gallery, Chicago

Robert Warrens. *Aesthetic Warrior*. 1984. 213.4 × 304.8 cm (84 × 120 in). Courtesy the artist

There is a kinship, for example, between Roger Brown's work and that of Gary Washmon (b. 1955). Washmon was born in Arizona, and received his masters degree in Fine Art from the University of Illinois, but has since spent much of his career teaching at the University of Texas. His work is marginally more naturalistic than that of Brown, showing traces of the original Regionalist heritage from the 1930s.

Louisiana artists often seem to specialize in fantasy. This plays a prominent role in the paintings and painted objects of Robert Warrens (b. 1933), who lives and works in Baton Rouge, and whose work represents the quintessence of this particular aspect of Louisiana art. Folk and narrative elements are especially clearly visible in the objects which he makes as alternatives to conventional canvases.

The most important of the regional American schools, but also the most difficult to define, is that of California. In fact, it consists not of one school or tradition, but several. There is, for example, a clear distinction to be made between the art produced in northern California and that which is made in and around Los Angeles.

One reason for the growing importance of Californian art is the growing wealth of the region, and the establishment during the 1980s of a museum infrastructure which had been lacking up to that point, especially in Los Angeles. Los Angeles now has three major institutional showcases – the Museum of Contemporary Art designed by Isozaki; the vast Temporary Contemporary (a converted police garage); and the new wing of the Los Angeles County Museum devoted to modern and contemporary art. This by no means exhausts the list of museums in the area – the Newport Harbor Art Museum in Newport Beach, for instance, also runs an innovative programme of contemporary exhibitions. There is a growing number of commercial galleries which specialize in contemporary art in Los Angeles itself and also in Santa Monica, where a stretch of Colorado Avenue is developing into the kind of densely packed gallery area that Los Angeles always lacked previously. In addition, Los Angeles now plays host to a major annual art fair. The fact that the city is in the process of becoming an important international art centre has brought increased respect, as well as many additional opportunities, to local artists.

The distinction between northern and southern Californian art is easier to draw if one looks first at the region in the north, around San Francisco. Perhaps the most striking characteristic of the painting and sculpture of this area is its continuing close alliance to the craft traditions which have always been powerful there. For instance, San Francisco has long been a prominent centre for the production of ceramic sculpture – among the leading practitioners are Robert Arneson and Viola Frey (see pp. 100, 102–3). When it first made its appearance, such sculpture was closely linked to the Funk Art movement which flourished in the Bay area during the 1960s. Funk, from the adjective 'funky' which originally meant simply 'smelly' and which later became a jive or hip-talk term meaning strange or *outré*, meant art which was bizarre and often in deliberate bad taste. Funk had strong stylistic connections with the Hairy Who and other similar Chicago groups, but was more fantastic and contained more autobiographical narrative. Much of the most typical San

Joan Brown. *In the Studio.* 1984. Enamel and acrylic on canvas, 243.8 × 198 cm (96 × 78 in). Courtesy Allan Frumkin Gallery, New York

reason for this may be the strength and bold experimentalism of local craftspeople working as 'fibre artists'. These have completely broken the boundaries of traditional weaving and papermaking techniques and create some of the subtlest abstract patterning now being produced in the United States. They are only omitted from this book because they themselves so firmly refuse to be labelled as painters, or indeed as any other variety of fine artist.

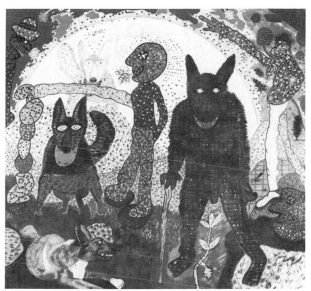

Roy de Forest. *Big Foot, Dogs and College Grad.* 1985. Polymer on canvas, 226.1 × 241.3 cm (89 × 95 in). Courtesy Allan Frumkin Gallery, New York

Francisco painting today continues to have autobiographical overtones, often laced with wry humour. This is true, for example, of the work of Joan Brown (b. 1938) – many of her paintings feature self-portraits. The autobiographical strain recurs in the art of Roy de Forest (b. 1930), locally known as the 'dog-painter' because so many of his works portray canines – he also has a penchant for giant rabbits. Roy de Forest is now best known for his later figurative compositions, but in tracing his development it is interesting to see that his early abstract work is very similar in basic style, and certainly in colour and handling, to that which he has done subsequently; the quirky figuration of recent paintings serves as a kind of 'come on', designed to persuade the spectator to take an interest in other qualities, such as the sumptuous colour harmonies.

In general, however, the most characteristic San Francisco painting tends to steer clear of abstraction. One

San Francisco art is often condemned by hostile critics for being (in their view) kitsch. Los Angeles art has attracted blanket condemnation for being superficial. Few accusations could be more unjust. One of the impressive things about southern Californian art today is the solidity of the local tradition and the wide variety of styles practised within this tradition but still bearing some relationship to it.

The oldest generation of Californian artists is represented by Sam Francis (b. 1923). Born in San Mateo, California, Francis is extremely widely travelled, and he has been influenced in particular by a long period of residence in Paris and by his connections with Japan. But he has,

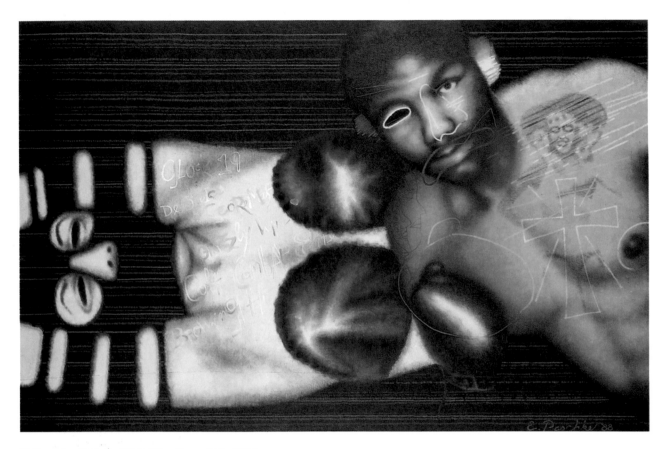

Ed Paschke. *Maîtrise.* **1980. Oil on linen, 127 × 198.1 cm
(50 × 78 in). Courtesy Phyllis Kind Gallery, New York and The
Mayor Gallery, London**

Ed Ruscha. *Woman from History.* **1986. Dry pigment and
acrylic, 152.4 × 102.2 cm (60 × 40¹/₄ in). Courtesy
Robert Miller Gallery, New York**

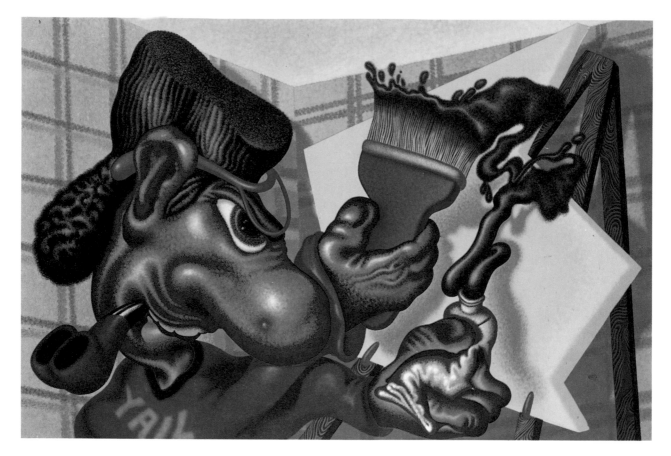

Peter Saul. *New York Painter*. 1987. Oil and acrylic on canvas,
182.9 × 274.3 cm (72 × 108 in). Courtesy Allan Frumkin Gallery,
New York

Roy de Forest. *The Compleat Life*. 1985. Polymer on canvas,
200.7 × 248.9 cm (79 × 98 in). Courtesy Allan Frumkin Gallery,
New York

from the early 1960s onwards, retained close links with California, and the airy elegance – one might almost say the dematerialization – of his style marks his work as being something quite different from the more aggressive Abstract Expressionism of the East Coast.

During the 1960s leading Los Angeles artists maintained a dialogue with what was happening in the East, often interpreting East Coast fashions in distinctly unfamiliar ways. This was true, for instance, of Billy Al Bengston (b. 1934) and of Ed Ruscha (b. 1937), both of whom owed something to the Pop Art movement without completely committing themselves to it. Bengston, for example, tried to find ways of integrating certain identifying symbols, such as the chevron or 'sergeant stripes', into what was primarily abstract work. He also experimented with materials, using high gloss enamels on dented metal, an allusion to the importance of the automobile in the local environment. While Bengston's work has been criticized for its lack of development in the 1970s and 1980s, Ruscha, originally famous for his sophisticated use of lettering and his high-gloss versions of 'typical' Californian images such as filling-stations, has embarked on a new stylistic phase in the current decade. His most recent all-grey canvases have a subdued romanticism, and seem to look back nostalgically to the days when the most famous Californian cultural product, the movie, made its most significant impact through the use of black-and-white. Even more specifically Californian are recent paintings by Peter Alexander (b. 1939). In 1982, Alexander, who had been an abstractionist, embarked on figuration with a series of seascapes featuring sunsets. He thus returned to a theme which had been

greatly favoured by Californian artists during the 1930s – so much so that the 'sunset picture' became established as a recognizable local genre. Reviving it, Alexander chose to exaggerate the vulgar aspect of his chosen imagery, sometimes even using glitter paints on velvet. The acknowledged irony is extremely typical of one aspect of southern Californian art.

Billy Al Bengston. *Tangier.* 1985. Acrylic on canvas, 226.1 × 218.4 cm (80 × 86 in). Courtesy James Corcoran Gallery, Los Angeles

Peter Alexander. *Marmolito*. 1985. Oil and wax on canvas,
121.9 × 134.6 cm (48 × 53 in). Courtesy James Corcoran Gallery,
Los Angeles

In the 1970s, southern Californian art took a new
direction, with the rise of the 'Light and Space' move-
ment. Artists associated with this included Robert Irwin
(b. 1928), whose softly lighted discs seemed to take art to
the very edge of perception, since the artwork consisted
not so much of the disc itself but the patterns of light sur-
rounding it on the wall; and James Turrell (b. 1943), who
also experimented with light, and in addition made
kinaesthetic experiments – for example, one designed to
demonstrate the effect that sound has upon taste. At this
period (1969), Irwin asserted: 'It is my contention that
modern art has been principally involved for twenty years
in a disengagement from literate thinking, to place an
emphasis on sensual awareness...'

Linked to the concern with light and space as media
which could be manipulated in their own right was a
more specific concern with the endangered environment.
The artists most strongly representative of this were
Helen Mayer Harrison (b. 1929) and Newton Harrison
(b. 1932). Married in 1953, the Harrisons began collab-
orative work in 1970, three years after settling in La Jolla,
California. In 1972 they started work on what is perhaps
their most ambitious creation, *The Lagoon Cycle*, which
was exhibited in (provisionally) complete form at Cornell
University in 1985. The cycle initially sprang from an
interest in a particular species of fast-growing crab, native
to Sri Lanka, which the artists thought might be a useful
alternative food source. The cycle is divided into seven

Helen and Newton Harrison. *First Lagoon Panel 7*. Oil, crayon and photograph on canvas, 190 × 152.4 cm (75 × 60 in). Private Collection

sections (or Lagoons), and is explained thus: '*The Lagoon Cycle* unfolds as a discourse between two characters, the Lagoonmaker and the Witness. The work is named for the estuarial lagoons that are endangered everywhere, the lagoon being a metaphor for life itself.' This work, a mixture of performance, pictorial metaphor, moral indictment and scientific research (the Harrisons were able to induce their crabs to breed under laboratory conditions, which scientists had previously been unable to do), is very typical of the way in which southern Californian art of all kinds rebelled against both conventional formats and traditional approaches in art.

Today, however, this rebellion seems to be on the wane. In this sense, *The Lagoon Cycle* is a culmination, not a new departure. Younger Los Angeles artists are more apt to be content with established categories. What they now have, as a legacy from the 1970s, is a stronger confidence in the validity of their own idiom, combined with a continuing interest in the symbolic. Typical are the paintings featuring crosses and primitive doorway shapes being produced by the painter Craig Antrim (b. 1943). Modest in scale but potent in effect, these seem curiously typical of a culture which notoriously combines a thrusting materialism with a restless search for other-worldly truths.

SCULPTURE

In the 1970s, sculpture, or forms of activity which described themselves as sculpture, was a primary element of avant-garde art. Both American Minimalism and Italian *Arte Povera* were essentially sculptural in their attitudes, and more often than not the artists connected with these movements expressed themselves through work in three dimensions. But during the decade the rise to prominence of new schools of painting offered sculpture a challenge which was reinforced by the shift from public to private patronage. Private collectors found many of the more typical kinds of avant-garde sculpture difficult to house and certainly not very suitable to the domestic environment. Certain sculptors did, however, benefit from the new situation, especially in America.

It is one of the curiosities of the history of modern sculpture in the United States that it lacks continuity – or, rather, that it finds continuity only within a broad stream of development which includes all forms of artistic expression. Thus David Smith, probably the most important American sculptor of the post-1945 period, makes better sense within the context of Abstract Expressionism, a movement primarily concerned with painting, than he does when compared to most of the American sculptors who preceded and followed him. Smith's work provides important indicators for the interpretation of American sculpture in the 1980s, but he is not the direct ancestor of most of the American artists now at work in this field.

An exception must be made in the case of Fletcher Benton (b. 1931) (though Benton's career has been based on San Francisco, whereas Smith is identified with the New York art world). One of the things which Benton has most in common with Smith is the fact that he makes sculpture with a painter's sensibility. At the beginning of his career he was in fact a painter, but in the early 1960s he met a major setback, when an exhibition of paintings featuring motorized elements, and showing images of high-kicking nude female circus performances, was cancelled on grounds of indecency. Benton was profoundly shocked and responded by moving into purely abstract kinetic work. In doing so, he caught the tide of the new Kinetic Art movement, then burgeoning in Europe, and he was hailed as its chief American representative.

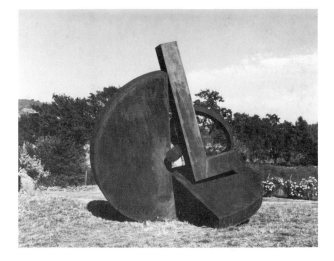

Fletcher Benton. *Folded Circle L Ring*. 1988. Steel, 3.2 × 4.3 × 6.5 m (9 × 12 × 18 ft)

For Benton, these first abstract pieces were not really sculpture. What led him to true sculpture was the problem of finding an appropriate housing for the motorized elements of his kinetic works:

The frames started taking over, and becoming more and more dimensional. They gradually became more and more of an object. By 1974 I felt that I had done the same thing with my Kinetic Art that I had done with my painting materials and attitudes: I simply got rid of it... I abandoned Kinetic Art because I felt I had gone as far as I could go with it, and there was no need to take it further.

Buried deep within the new work, however, were ideas and preoccupations he had had when he was still a painter.

Here it is possible to make several direct comparisons with David Smith. Smith regarded much of his early sculptural work as a form of drawing – some early sculptures based on landscape imagery were made directly from drawings which were almost purely calligraphic rather than three-dimensional. Later, when he worked on a much larger scale, it was Smith's practice to assemble the materials he used – metal offcuts and bits of industrial detritus – in various configurations on a flat surface, thus giving a profile view of the piece before welding it together. Though various adjustments were made,

Tony Cragg. *Red Indian*. 1982. Plastic,
320 × 210 cm (126 × 82¹/₂ in). Courtesy Lisson Gallery, London

George Segal. *Helen against Door*. 1988. Plaster, wood and
acrylic paint, 121.9 × 66 × 38 cm (48 × 26 × 15 in). Courtesy
Sidney Janis Gallery, New York

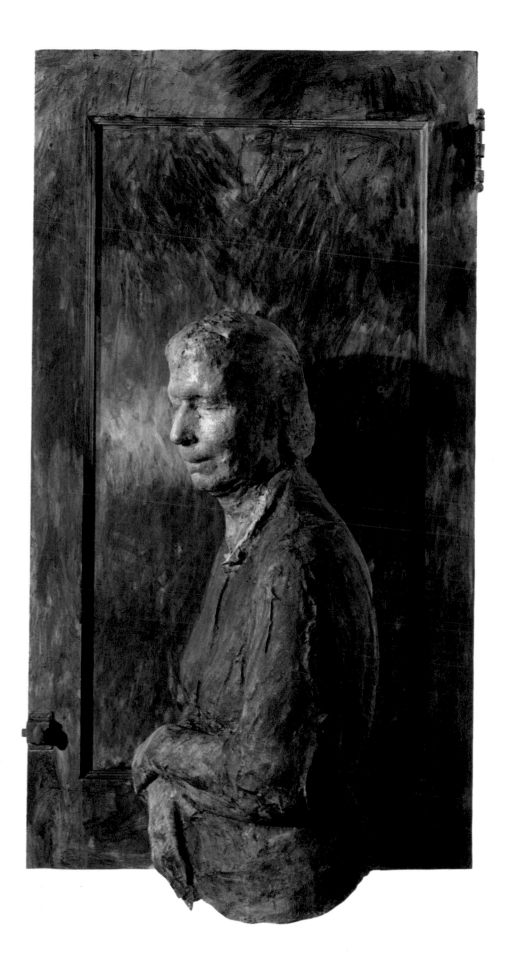

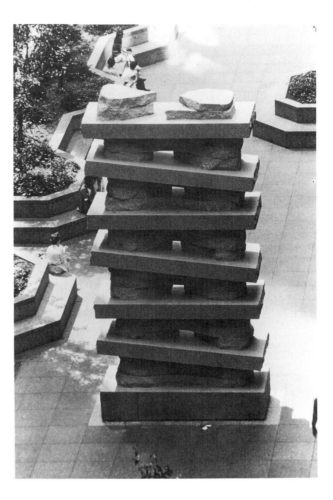

Smith's work is often more two-dimensional than it is three-dimensional, simply as a result of his basic working methods.

Benton has been conscious of this example, as can be seen from an ongoing series which he describes as *Steel Watercolours*, which actually had its beginnings in a series of watercolours made when he was rebuilding his studio and unable to work on a large scale. Other works are made by 'discovering' all the forms to be used within a single flat sheet. Many of these sculptures derive from standard letter forms, a nostalgic look backwards at Benton's early career as a signwriter.

Benton's work differs from Smith's in that he is more prone to invent forms than to find them ready-made in the guise of industrial leftovers. His sculpture is also less romantic, less rhetorical and more playful. What it does have in common with Smith, in addition to its debt to painterly ways of thinking, is its ability to encompass the monumental. Living as he does on the West Coast, Benton has been able to provide himself with the facilities necessary for working on such a scale (now almost an impossibility in New York, simply for economic reasons, as he points out), and he has also found clients with an appetite for large open-air pieces and with the places to site them.

Another sculptor who has benefited from a similar kind of situation, in terms of both working conditions and patronage, is the Texas-born Jesus Bautista Moroles (b. 1950), who has a large workshop near Rockport, Texas, and a studio near Santa Fe, New Mexico. Where Benton works in metal, Moroles uses stone — very often the native Texas granite. Moroles's sculptures often allude to landscape imagery, and here, too, there is a real though more distant resemblance to David Smith. In other works, the allusion is to pre-Colombian architecture — something which suggests a link to South American artists such as Torres-García and the contemporary Uruguayan Gonzalo Fonseca. Moroles himself is of Mexican descent.

Moroles, like Benton, often works on a monumental scale. He treats stone in a distinctly industrial way, sawing it into flanges. These deep regular cuts are only possible with the use of machinery. His work successfully straddles two concepts: it speaks of the land itself and of the early civilizations which arose in America; yet it also speaks of the industrial present.

Benton and Moroles, being abstract sculptors whose work is nevertheless filled with hidden allusions to recognizable things and objects, stand between the two camps into which American sculpture seems currently to have divided itself. On the one hand there are the Minimalists, who continue without much variation a style which was already firmly established nearly two decades ago; and on the other hand there is an increasing interest in figuration. One source of the figurative impulse is the continuing tradition of Pop Art, though Pop sculpture has now undergone some drastic transformations. In the case of George Segal (b. 1924), it is a transformation of use, rather than a transformation of style. Segal's early work was a form of domestic genre and was unsuitable for outdoor monumental purposes simply because of the materials employed. Since then Segal's concerns have become commemorative and humanistic. Instead of being at emotional arm's length from his subject-matter, he identifies with it, and he has become the sculptural advocate of innumerable good causes such as Gay Liberation. The fragile materials he once used have been

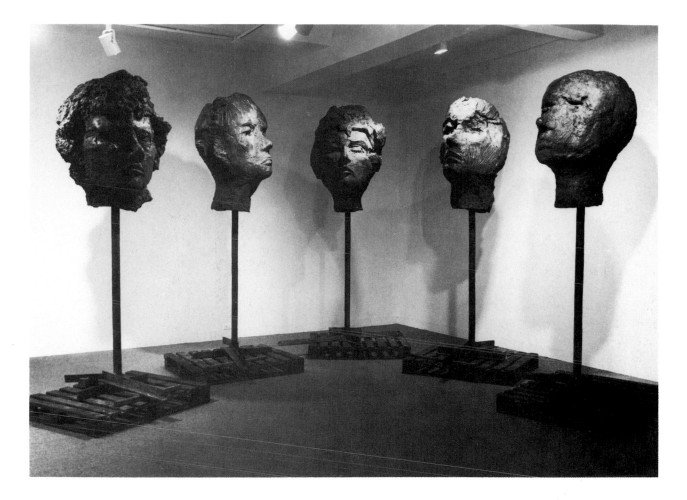

exchanged for more permanent ones, though bronze is often patinated to resemble the plaster he once favoured.

Jim Dine (b. 1935) has dramatically extended his range by moving into sculpture. His early paintings often featured collage elements, and these survive in some of the sculptures. But Dine's sculptures are in general surprisingly traditional – for example, his portrait heads of his wife Nancy, sensitive and Rodinesque despite their gigantic scale. Other works hint at an affinity with traditional Surrealism, among them Dine's paraphrases of the Venus de Milo (shown without her head). In one version, the bronze is patinated in a medley of garish colours; in another, there is a saw which is about to bite into the figure's knee. One recalls that the image of the Venus de Milo also fascinated Magritte.

Robert Graham (b. 1938) has more tenuous links with Pop, though his very earliest works – tiny wax figures in exquisitely detailed environments, often shown under glass domes – certainly had something to do with the Pop ambience. In the early 1970s Graham began making figures in bronze, and this is the direction he has taken ever since. His figures and part-figures – females, more infrequently males, and sometimes horses – are usually

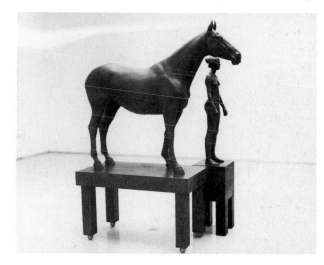

Jim Dine. *Five Heads in London.* **1983. Bronze, central head 287 × 135.9 × 120.7 cm (113 × 53¹/₂ × 47¹/₂ in). Courtesy the Pace Gallery, New York**

Robert Graham. *Spy & Stephanie.* **1981. Bronze, 180.3 × 142.2 × 35.6 cm (71 × 56 × 14 in) & 156.2 × 29.2 × 19.1 (61¹/₂ × 11¹/₂ × 7¹/₂ in). Courtesy Robert Miller Gallery, New York**

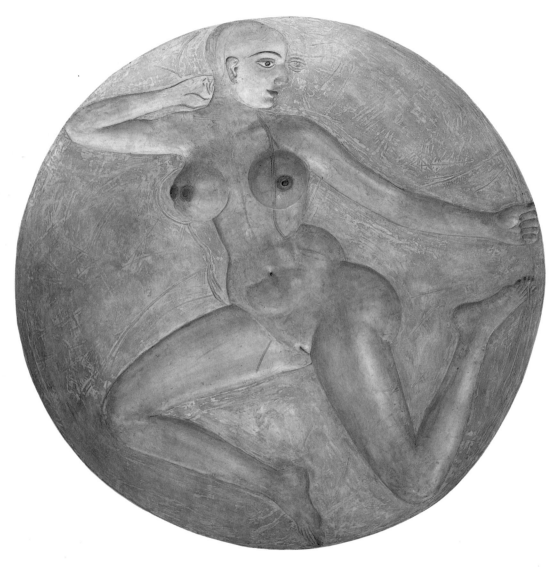

Dhruva Mistry. *Maya Madallion: The Dark One – 2.* **1987. Acrylic paint on plaster,
119.5 × 7.5 cm (47 × 3 in). Collection: Tate Gallery, London.
Courtesy Nigel Greenwood Gallery, London**

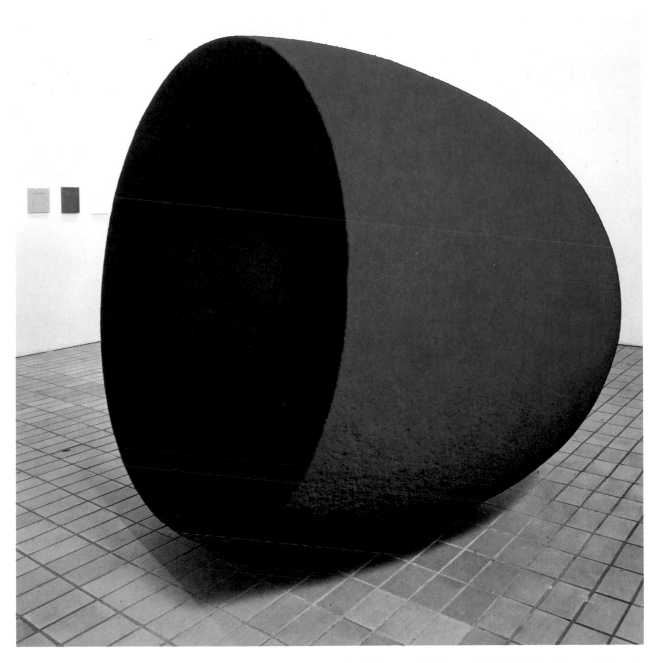

Anish Kapoor. *Mother as a Void.* **1988. Fibreglass and pigment, 205 × 205 × 230 cm (80³/₄ × 80³/₄ × 90¹/₂ in). Collection Musée St. Pierre, Lyon. Courtesy Lisson Gallery, London**

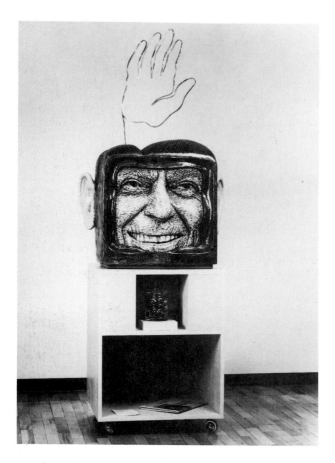

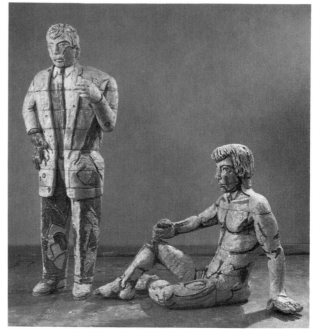

Viola Frey. *Nude Man & Mass Man.* 1980. Ceramic,
172.7 × 233.7 × 165.1 cm (68 × 92 × 65 in). Courtesy Nancy
Hoffman Gallery, New York

Robert Arneson. *Ronny.* 1986. Glazed ceramic, wood, metal and
found objects, 120.7 × 76.2 × 66 cm (47¹/₂ × 30 × 26 in). Courtesy
Frumkin/Adams Gallery, New York

somewhat below life-size and are often presented on tall
bases which form an integral part of the sculpture. The
importance of the base sometimes leads to analogy with
the work of Giacometti, but the comparison which sug-
gests itself even more insistently is one with the bronzes of
Degas. Yet compared with Degas's treatment of the same
subject-matter, Graham's work is conspicuously cold and
often skirts the borders of academic classicism. His im-
mense success with the patrons of the 1980s reflects not
only the positive attraction of his work, but the negative
reactions inspired by other kinds of sculpture.

A number of leading American sculptors, particularly
those from the West Coast, have chosen ceramic as their
preferred medium. Many of them show a wish to demys-
tify the whole process of making art and they are often
interested in the use of colour. Robert Arneson (b.1930)
was associated with the Funk Art movement. Arneson's
early sculptures were often offbeat self-portraits, and this
tendency continued into the 1980s. *California Artist*,
made in 1982, is an ironic homage to a New York critic
who accused Arneson's work of lacking depth. Dark
glasses reveal a totally empty head; a marijuana plant
grows up the pedestal supporting the half-length figure,
which is shirtless and wearing only a rumpled denim
jacket.

Other sculptures made by Arneson in the 1980s are,
however, deadly serious — they represent the victims of
nuclear war, with the generals and others who are respon-
sible for making war transformed into half-demonic
beings. This is propaganda art of a kind which seems to
look back to Weimar Germany, for instance, to the
photo-collages of John Heartfield.

Viola Frey (b.1933) makes sculptures in ceramic where
the main influence seems to come from traditional folk
art, rather than from Pop imagery. Her figures are large in
scale, rather primitive in modelling, and radiate a pathos
which makes them memorable. Stephen de Staebler
(b.1933) creates figurative ceramic sculpture which
is different again. His standing personages are riven,
torn, in some degree fragmentary. They seem wrenched
from some architectural context — relics of a forgotten
civilization. In the 1960s, de Staebler worked with the
leading American ceramicist Peter Voulkos, a great
advocate of total spontaneity in the use of materials, and
de Staebler's work continues to bear the marks of this even
when, as sometimes happens, he prefers to work in
bronze.

One of the most interesting developments in recent
American sculpture is for the artist to use some related
form of activity — something which comes close to art

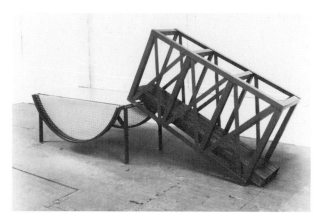

Siah Armajani. *Element # 18.* 1988. Aluminium, painted steel
and pressure-treated wood, 172.7 × 360.7 × 101.6 cm
(68 × 142 × 40 in). Courtesy Max Protech Gallery, New York

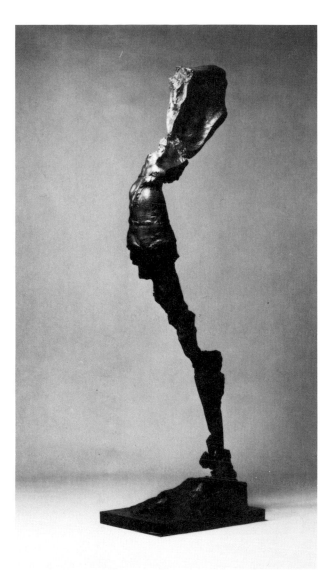

Stephen de Staebler. *Archangel.* 1987. Bronze,
302.2 × 67.3 × 87.6 cm (119 × 26¹/₂ × 34¹/₂ in). Courtesy CDS
Gallery, New York

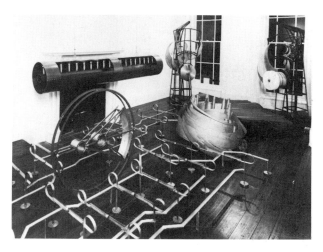

Alice Aycock ... *Theory of Universal Causality (Time/Creation
Machines).* 1982. Courtesy the artist

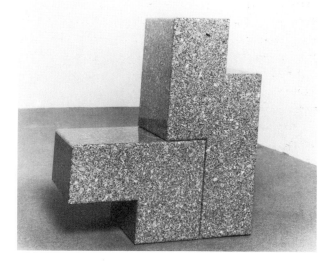

Scott Burton. *Two Part Chair.* 1986. Granite,
101.6 × 58.4 × 91.4 cm (40 × 23 × 36 in). Courtesy Max Protech
Gallery, New York

without actually being art – as a vehicle for what he or she
wishes to say. An example of this is the work of Siah
Armajani (b. 1939), which consists of architectural frag-
ments, often in forms and materials which stress that they
are not meant for practical use. Another example is Alice
Aycock (b. 1946), many of whose sculptures resemble
mysterious machines, once again without an obvious
practical use. Perhaps the most striking instance of this
tendency, however, is Scott Burton (b. 1939). Burton has
achieved international celebrity as 'the man who makes
chairs'. Every sculpture, whatever its materials, is also a
piece of furniture. As Burton himself said to an inter-
viewer: 'In a sense, I'm an impersonator – I'm im-
personating a furniture designer. Now I know that will
make some people uncomfortable, but I've come to

Viola Frey. *Reclining Nude.* 1987. Glazed ceramic,
101.6 × 276.9 × 124.5 cm (40 × 109 × 49 in). Private Collection

Robert Arneson. *California Artist.* 1982. Glazed ceramic,
198.1 × 71.1 × 53.3 cm (78 × 28 × 21 in). Courtesy Allan Frumkin
Gallery, New York

Richard Long. *Somerset Willow Circle*. 1980. 484 sticks, 548.6 cm
(216 in) diam. Courtesy Anthony d'Offay Gallery, London

furniture the way Andy Warhol came to film when he
started making movies in the sixties.' The historical con-
trast is interesting – in the late 1960s American sculpture
reduced itself to a minimum, and assumed the unitary
forms of Minimal Art. Burton, in the 1980s, goes a little
beyond that – he takes sculpture to the point where it
more or less disappears. He has even admitted to taking
out a patent on one of his chair designs: 'That's a real
statement about my intention. The guy told me you can't
patent a work of art.'

In Europe, the most active school of sculptors has been
the British. This has pursued a different and more coher-
ent course from that of sculpture across the Atlantic. The
most significant British sculptor of the 1970s was
Richard Long (b. 1946). Long's radical redefinition of the
word sculpture, combined with an element of traditional
nature-worship, gave his work surprisingly wide appeal.

His most characteristic 'sculptures' consisted of works
made on the spot with immediately available materials.
Often the only proof of their existence was the pho-
tographs Long himself took of them – for example *A
Circle in the Andes* (1972), which consisted of a large circle
of boulders and small pebbles on a remote South Amer-
ican plateau. These works were evocative in the way that
Claude's landscapes or the ink-and-brush paintings of
Chinese scholar-virtuosi are evocative. They speak of an
infinitely refined sensibility, a nostalgia for remote places
and things.

Tony Cragg (b. 1949) uses methods familiar from
Long's work – accumulation and assemblage – but his
relationship is not with nature, rather it is with industry
and the man-made. His sculptures are made not from
stones and twigs but from bits of industrial detritus. In
one statement he notes:

I am not interested in romanticizing an epoch in the distant past
when technology permitted men to make only a few objects,

tools etc. But in contrast to today I assume a materialistically simpler situation and a deeper understanding of the making processes, function and even metaphysical qualities of the objects they produced. The social organizations which have proved to be most successful are productive systems. The rate at which objects are produced increases; complementary to production is consumption. We consume, populating our environment with more and more objects, with no chance of understanding the making process because we specialize, specialize in the production, not the consumption.

In a sense, most of Cragg's sculptures seem to be intended as moral emblems of the consequences of production. Some are piles of scrap materials, others are wall-pieces made of plastic fragments (Cragg considers coloured plastic to be particularly important as an emblem of our current material culture). The wall-pieces in plastic are often figurative – one takes the shape of a Union Jack; another that of a Polaris submarine.

Cragg has no recognizable style as such and therefore is not stylistically imitable. But his conception of what sculpture is, or should be, has influenced a number of other British artists. One of the most striking of these is Anish Kapoor (b.1954). Kapoor is of partly Indian, partly European parentage, and his work is related to Hindu culture as well as to that of Europe. Perhaps the best way of describing his work is to say that the sculptures are tantric objects reinvented in the light of European modernism.

One of the striking things about Kapoor's work is its uninhibited use of colour. At first he applied colour using loose powder, but now (for practical reasons) he makes it cling more closely to the sculptures, which often resemble greatly enlarged seeds or fruit. These powdery saturated hues are very much those of Indian folk art.

Kapoor is just one of a group of artists working in England who have been exploring the meaning of the Indian heritage. Some of these are actually Indian by birth – probably the best-known in this category is Dhruva Mistry (b.1957), who comes from Kanjari and whose work is heavily influenced by Indian folk art. Stephen Cox (b.1946), an English artist who has visited India and worked there, is fascinated by the forms of Indian classical sculpture.

Dhruva Mistry. *Little Bird*. 1985. Plaster, 145 × 112 × 48 cm (368¹/₂ × 248¹/₂ × 122 in). Courtesy Nigel Greenwood, Gallery, London

Stephen Cox. *Sorgente*. 1987. Peperino, 100 cm (39¹/₂ in) diam., 16 cm (6¹/₄ in) deep. Private Collection. Courtesy the artist

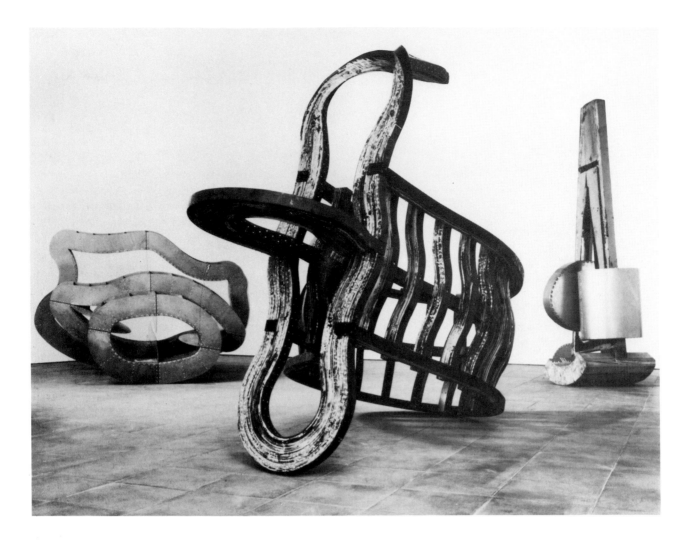

Other examples of the 'emblematic' way of working –
searching for emotionally associative rather than merely
formal relationships – represented by Cragg and Kapoor
are Richard Deacon (b. 1949) and Anthony Gormley
(b. 1950). Here, too, the work is strongly contrasted in
actual appearance. Deacon describes himself as follows:

I am a fabricator, not a carver or a modeller. In this sense manu-
facturing or building skills are of little interest to me.

 Resonance is a central preoccupation. Some issues are rela-
tively simple. I work with materials in the most straightforward
way. I do not make plans. The activity is repetitious. There is no
sense in making things complicated. I begin by shaping stuff,
most recently into circles or cones, and continue by developing
the form. I may have something in mind or I may not. There are
often radical changes. The unexpected happens. I am never sure
whether I finish the thing I am making or whether it finishes
with me.

Despite his emphasis on fabrication, however, Deacon
remains a symbolist in quite a narrow sense of the term.
He has been strongly influenced by the poetry of the great
German Symbolist writer Rainer Maria Rilke, and sees

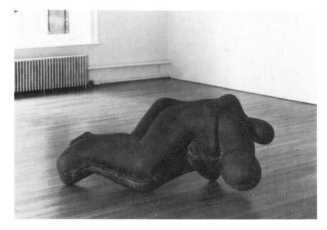

Richard Deacon. Left to right: *Troubled Water.* **1987.** *Fish Out of*
Water. **1987.** *Feast for the Eye.* **1987. Installation shot, Lisson**
Gallery, March–April 1987. Courtesy Lisson Gallery, London

Anthony Gormley. *Holding On to the Future.* **1987–8. Cast iron**
and air, 73.7 × 172.7 × 86.4 cm (29 × 68 × 34 in). Courtesy
Salvatore Ala, New York

the objects he creates in space as being metaphors for sound, just as Rilke himself evokes space through sound.

Anthony Gormley works in a very different way. The bulk of his sculptural output consists of extremely simplified manikin-like figures, created from moulds of Gormley's own body. The base material used to be plaster, overlaid by sheets of lead carefully soldered together. More recently Gormley has turned to working in iron, but the shapes remain the same. His work might seem to have something in common with that of George Segal, which also depends on making a mould from the human body. But, unlike Segal, Gormley is not interested in anecdotal details – he wants to create a symbolic stereotype. In a number of his more recent works, there is deliberate distortion: the elimination or exaggeration of some part of the body, which makes it plain that the main purpose of the sculptures is symbolic.

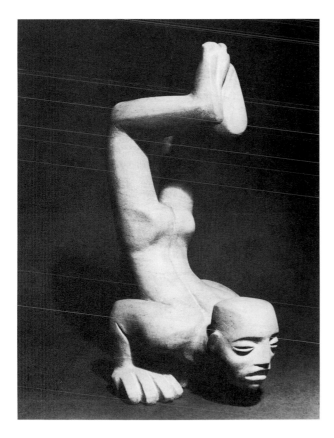

Glynn Williams. *Handstand* 1982. Ancaster stone, 45.7 cm (18 in) high. Courtesy Blond Fine Art Ltd, London

Among Gormley's acknowledged sources are William Blake and, perhaps more unexpectedly, Jacob Epstein. His interest in and affinity with Epstein is one signal of a new and interesting development in British sculpture – the return of some of the ideas of early modernism. The standard-bearer of this tendency, and consequently one of the most controversial artists of the 1980s, is Glynn Williams (b. 1939). Williams's development has not been an orthodox one. Even in the earliest period of his career, it was evident that he was a brilliant virtuoso stone-carver. In the 1960s, however, this skill seemed irrelevant, and he was attracted to mixed-media work, to collage, and above all to a kind of radical abstraction based partly on the Brancusi of the *Endless Column* and partly on the reductionist aesthetic which was to inspire Minimalism in America.

By the beginning of the 1980s Williams was ready to return to figurative work. His new sculptures did not renounce modernism. *Two Sisters* (1982) is a homage to Matisse, as well as a tribute to his own daughters. He also looked at the kind of non-European art which had inspired both Epstein and Moore. *Handstand* (1982) has hints of Aztec art about it. But his new sculptures were unrepentantly figurative, and the ideas they dealt with were more than purely formal ones.

Williams's change of direction aroused an immense hostility in the British sculptural establishment which is only just beginning to die down. Not the least of his offences was his undoubted virtuosity in handling his material – for his critics, this became almost a proof of vulgarity and insincerity. His example did, however, have a marked effect on younger sculptors, especially those whom he came into contact with through his activity as a teacher, and there is now in Britain a whole school of figurative sculptors waiting to emerge.

It is interesting to compare the development of Williams's work, and the reception accorded to it, with that given to Barry Flanagan (b. 1941). Flanagan first made an impact as a proto-Minimalist in the late 1960s, using materials, such as sacking and rope, which were also associated with the work of the *Arte Povera* group in Italy. By the early 1970s he was already making stone carvings, which featured a rather gnomic figuration. Some were rudimentary forms which hinted at the exist-

ence of a figure, others showed a tantalizing resemblance to some natural object, such as a shell. Others were blocks or conical stone shapes engraved with designs. These latter seemed to allude to ancient Celtic art. At the beginning of the 1980s Flanagan turned to making figurative sculpture in bronze.

His figurative work is very different in approach from Glynn Williams's. While Williams's sculptures depend for their effect on his own skills as a carver (though recently he has taken to having some of his maquettes cast in bronze), Flanagan's art is a collaborative effort, as the artist himself was at pains to spell out in the catalogue preface to his first exhibition of sculpture in bronze held at the Waddington Galleries in 1981. This preface read in part:

By the close of the seventies, fashion and aspirations had been continuously qualified by larger external events, and expedients of production put into perspective. The introduction of some concept of trade, drawing on the traditional resources of practice to produce sculpture, became necessary. When out of the garret one no longer works alone, but finds a place in a scheme of things. I am glad to point out that in the production of these pieces in bronze the *work* has been done by others, leaving only the modelling bits to me, as author. Thank you.

Many of Flanagan's early bronzes feature a whimsical image of a hare. Sometimes the hare is combined with another object, such as a helmet or a bell. The modelling is often deliberately rudimentary. The spectator is left in doubt as to how seriously the work to meant to be taken. The material signals serious intentions; the image ironically contradicts them.

Soon after he began working on the series of hares, Flanagan became interested in another theme – that of the horse. He was inspired by the exhibition devoted to the bronze horses of San Marco, Venice, held at the Royal Academy in London in 1979. Flanagan's horses are not new creations – they are replicas, though on a smaller scale, of the antique original. Sometimes the horse is rather crudely married to a monkey, which rides on its back. Here, too, there is a spirit of ironic contradiction.

Barry Flanagan. *Bronze Horse.* **1983. Bronze, 190.5 × 20.7 × 53.3 cm (75 × 79 × 21 in). Courtesy New Art Centre, London**

By replicating an existing and indeed very celebrated sculpture, Flanagan has aligned himself with 'Appropriation' – the label given by American critics to Jeff Koons's replications of pre-existing objects, and also to the presentation of consumer goods as pieces of art, as exemplified by Koons and Haim Steinbach. The ultimate source for this kind of activity is Marcel Duchamp, the inventor of the Ready-made. Glynn Williams's work shows no trace of any affiliation with Duchamp, and though he and Flanagan resemble one another in being sculptors who have at the same moment returned to figuration and the use of apparently traditional techniques (bronze casting and stone carving) there is thus a fundamental difference of aim.

Critics and curators who pride themselves on their support of the avant-garde have found it easier to accept Flanagan's recent work than Glynn Williams's, because the former pays tribute to the Duchampian ethos when returning to the past, while the other refuses to do so. Williams's figurative work has been the target, on occasion, of such extraordinarily virulent critical attacks, that one is forced to conclude that it represents a real threat to the *status quo*.

POST-MODERNISM

Barry Flanagan's replication of one of the horses of San Marco – a classical image – links him to Post-Modernism. This term was not, when it first began to be used, applied to painting and sculpture. It became current in the 1970s as a way of describing a new kind of architecture which was in the process of breaking away from the International Modern style associated with the leading Bauhaus architects and Le Corbusier. Post-Modern architecture had two notable characteristics: it saw the creation of a coherent symbolic language as being an important part of the architect's job; and it very often made a return, if not always in a very orthodox spirit, to the established grammar of classical forms.

The subsequent use of the word Post-Modernism to describe painting and sculpture has been somewhat imprecise. One gets the feeling that the theorists of Post-Modern architecture have been recruiting allies *ad hoc* to serve their own cause. On the other hand, there is no doubt that the 1980s have witnessed a widespread questioning of the attitudes and values of the Modern Movement, and that this questioning has been embodied in works of art which run counter to established modernist expectations.

Post-Modern art can be divided geographically. It takes on a slightly different nuance in each of the three regions where it has flourished most successfully – Italy, the United States and England. Italian artists, for example, have tended to stress the classical element, and it is in Italy that the new tendency first showed itself in aggressive, not to say polemical form, taking the name *Pittura Colta* – Cultivated Painting. This label was invented by the Italian critic Italo Mussa, and was used by him as the title of a book published in 1983. Carlo Maria Mariani was already creating work in neo-classical style in the early 1970s, and Mussa produced a monograph about him in 1980. It is clear from this publication that Mariani's work is rooted in three things – in the later work of Giorgio de Chirico, with special reference to the *Gladiators* and the *Mysterious Baths*; in the Conceptual Art movement, very strong in Italy during the 1970s; and in the neo-classicism of the late eighteenth and early nineteenth century. Mariani seems to have chosen neo-classicism because it was already an art of paraphrase and restatement – it is noticeable that he subtly exaggerates the characteristics which divide the neo-classical version or copy from the truly classical original.

During the 1970s Mariani was at pains to emphasize the role played by imitation in his work – he made versions of Raphael, Mengs and Guido Reni, and a version of David's *Marat* which included the figure of Charlotte Corday, exiting after her crime. Since that time Mariani's work has become less directly imitative but maintains the mask of neo-classical anachronism. Looking at his paintings, one might well feel, at least for a passing moment, that one was in the presence of a newly discovered canvas by the leading Milanese neo-classicist Andrea Appiani (1754–1817), or a painting by Mariani's declared idol, Angelica Kauffman (1741–1807).

Alberto Abate. *Gorgonica.* **1984. Ink and crayon on paper, 101.6 × 71.1 cm (40 × 28 in). Courtesy Jack Shainman Gallery, New York**

Nick Boskovich. *Heart Shattered.* **1986. Oil on paper,
12.7 × 17.8 cm (5 × 7 in). Private Collection**

Stephen McKenna *Two Black Diamonds*. 1986. Oil on canvas, 100 × 150 cm (39.4 × 59 in). Private Collection

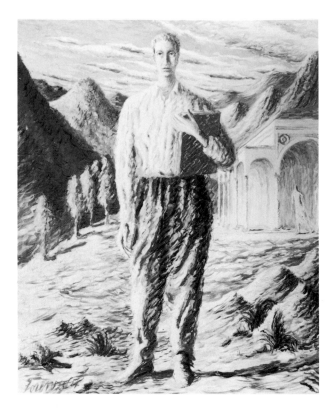

Lorenzo Bonechi. *Il Loggiato*. 1984. Oil on canvas,
248.9 × 198.1 cm (98 × 78¹/₂ in). Courtesy Sharpe Gallery,
New York

Fassianos. *Ceres*. Oil on canvas, size unknown. Courtesy
Zoumboulakis Gallery, Athens

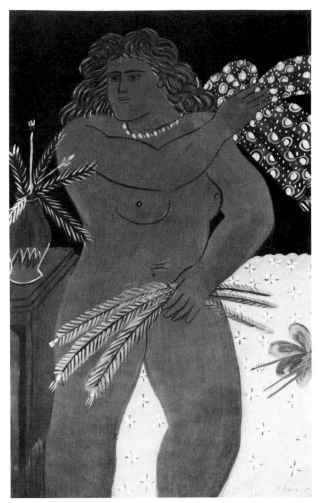

Mussa and other Italian critics friendly to *Pittura Colta*
have grouped a number of other artists round Mariani.
They include Alberto Abate (b. 1946), Lorenzo Bonechi
(b. 1955) and the Frenchman Gerard Garouste. To this
list one might also add the name of the Greek artist
Fassianos, who also concerns himself with classical
themes. None of these artists, however, is quite as con-
vincing in the assumption of a classical mask as Mariani
himself.

The mock classicism of Italian *Pittura Colta* returns in
different form in the work of the French artists Anne and
Patrick Poirier (both b. 1942). The Poiriers make assem-
blages, environmental pieces and architectural models
which evoke the splendour of the antique world. As Anne
Poirier puts it:

Our work attempts to reach a certain collective unconscious, or
common collective memory. Hence a certain mythology. Like
archaeology and architecture, it is an integral part of our mental
landscape; it is a veritable storehouse of images. Moreover, like
archaeology, mythology is also a metaphor of our mental func-
tions, of the unconscious, and is used by both Freud and Jung.

Anne and Patrick Poirier. *Fragility of Power*. 1988. Polished
aluminium, 149.9 × 116.8 × 116.8 cm (59 × 46 × 46 in). Courtesy
Sonnabend Gallery, New York

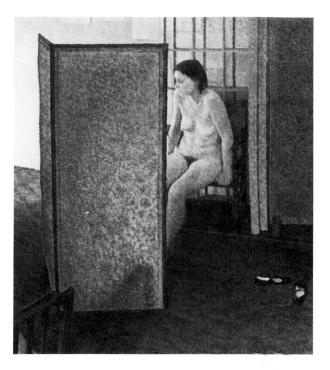

In addition, mythology is an inexhaustible theme of inspiration throughout the history of art. Perpetually reinterpreted, it takes each time a new dimension and can still be used for a long time. But a fable, like history, is only a pretext.

To put it another way, the Poiriers aim to transport the spectator to a dream world analogous to that of de Chirico's *Mysterious Baths*.

It is interesting to compare the attitudes adopted by the Poiriers to those of another French artist – the Hungarian-born Tibor Czernus (b. 1927). Czernus is not 'classical' in the strict sense, but his paintings are, nevertheless, allusions to the past – to art which possesses classic status. His exemplars are Caravaggio and his Neapolitan followers. Czernus denies that his intention is to imitate these artists directly. What he wants to do, he says, is: 'To re-experience the same adventure.' When one considers Czernus's powerful chiaroscuro compositions, the difference which gradually makes itself felt is the lack of specific narrative reference. Most of Caravaggio's mature masterpieces are direct narratives using sacred themes. In Czernus's paintings the narrative is suspended, the dramatic moment left ambiguous and unresolved.

His art is in some ways comparable to that of the Chilean emigré Claudio Bravo (b. 1936). Bravo spent a period in Spain but now lives and works in Morocco. His paintings show the influence of classicism – he is fond of painting interiors with classical statuary – but also that of seventeenth-century Spanish painting, notably Zurbarán. What links him most closely to Czernus is not this, however, but a lack of narrative resolution, and the fragmented sensibility which this suggests.

In Britain, the best-known Post-Modernist painter, often cited as typical of the style, is Stephen McKenna (b. 1939). Like Carlo Maria Mariani, McKenna sometimes paraphrases the art of the past in a way which stresses his distance from it almost as much as his sincere admiration. Unlike the stunningly accomplished Claudio Bravo, he seems to embrace a kind of deliberate clumsiness to emphasize the contrast between his work and that of his classical models. Some recent versions of Pompeian frescos supply a case in point.

William Wilkins (b. 1938) has also attracted the attention of Post-Modernist theoreticians. Charles Jencks, for example, has praised him for the fact that 'Each level of reality is a perfectly plausible world of painting or myth.' Wilkins's art is a fascinating combination of sources and influences. Probably his most important influence is Seurat, and like Seurat he tries to combine the quotidian with a sense of harmonious classical order. A painting like *Picnic*, however, spreads its net much wider than this. Also clearly present are Manet's *Dejeuner sur l'herbe* and

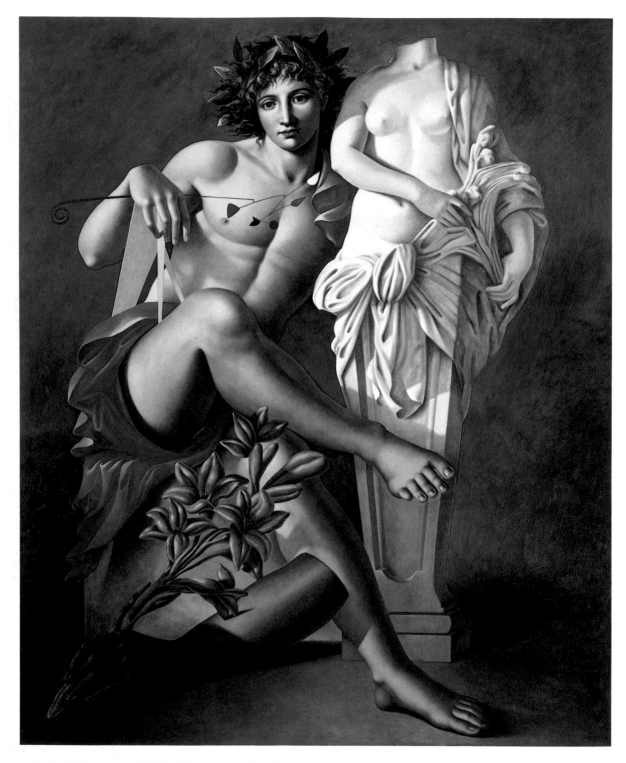

Carlo Maria Mariani. *April.* 1988. Oil on canvas, 230 × 190 cm
(90¹/₂ × 74³/₄ in). Courtesy Studio d'arte Cannaviello, Milan

Tibor Czernus. *Untitled.* 1987. Oil on canvas, 195 × 130 cm
(76³/₄ × 51¹/₄ in). Courtesy Claude Bernard Gallery, New York

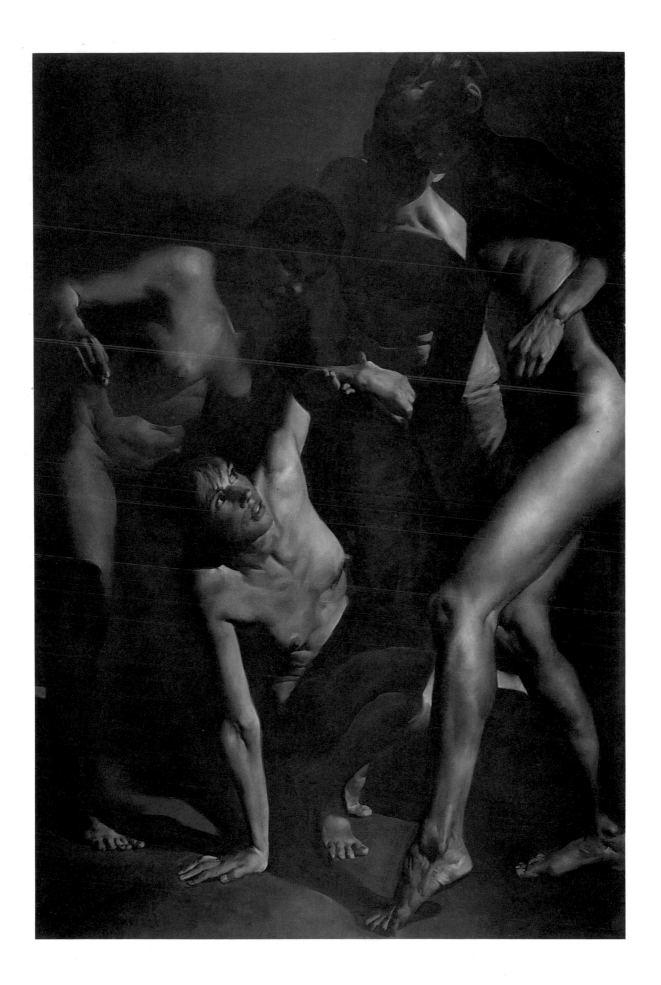

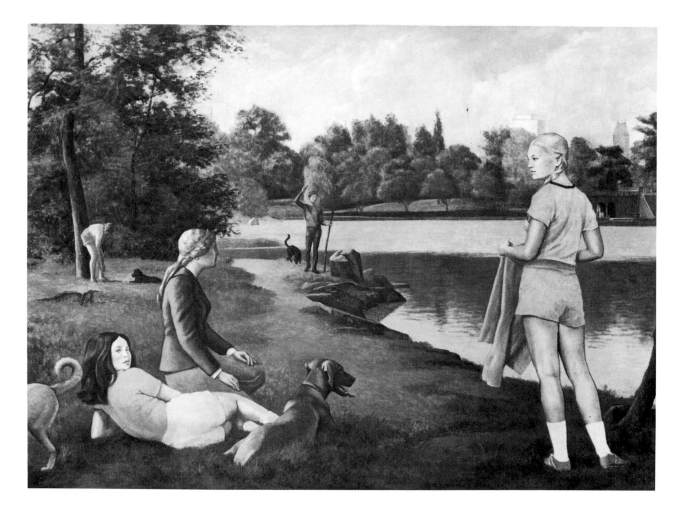

Milet Andrejevic. *The Encounter*. 1983. Oil on canvas, 91.4 × 127 cm (36 × 50 in). Courtesy Robert Schoelkopf Gallery, New York

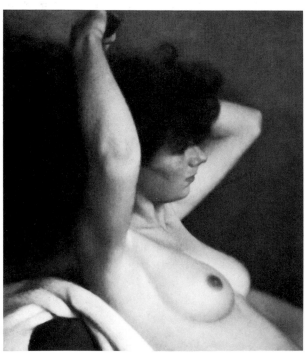

Michael Leonard. *Girl with a Hairbrush*. 1988. Alkyd-oil on masonite, 47.6 × 43.2 cm (18³/₄ × 17 in). Courtesy the artist

the *Bacchanals* of Bellini and Titian. Painting of this sort presupposes a very sophisticated audience, able to appreciate all the art-historical points being made. Post-Modernism, like Mannerism, is above all else a learned style.

Perhaps the most unaffectedly classical painter in Britain is Michael Leonard (b. 1933). A large part of Leonard's current output consists of solitary nudes, male and female, painted with infinitely refined gradations of tone. The point of each picture lies in the relationship between the figure and the rectangle which contains it. Though the paintings are apparently intensely realistic, they are in fact based on the abstract relationships of solid and void. A similarly classical spirit pervaded an earlier group of paintings which featured scaffolders at work. Here the scaffolding poles were often used to provide the composition with a rigid geometrical framework.

In the United States the Post-Modernist spirit has flourished on both the East and West Coast. There is,

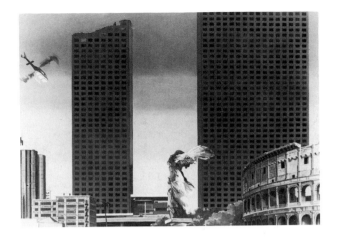

however, a difference in the way that it manifests itself. In the East, it tends to be self-consciously allusive – as it is in the witty paintings of Milet Andrejevic (b.1925). Andrejevic is perhaps best known for compositions showing groups of contemporary figures in New York's Central Park. The imagery and the way it is used suggests a comparison with what William Wilkins is doing in England – Seurat and Poussin are both present. So too, however, is Balthus, whose early masterpiece *The Street*, exhibited in New York's Museum of Modern Art, has clearly had a crucial impact on Andrejevic and many other American artists.

A classical realist who takes a less ironic approach to his material is Steve Hawley (b.1950), who lives and works in Connecticut. Hawley is fascinated with technical intricacy, and uses a technique which mingles oil and encaustic. The lustrous surfaces of his paintings are built up using an elaborate method of glazing. Especially impressive are his ambitious still lifes, which generally have an element of *trompe l'oeil* – something which can be traced back to the nineteenth-century American still-life painters William Harnett and John Peto. Like many still-life painters in the past, Hawley is also an allegorist – he is a devout Christian, and the fish that dominates the composition in the example shown here (p.118) is a piece of traditional Christian symbolism.

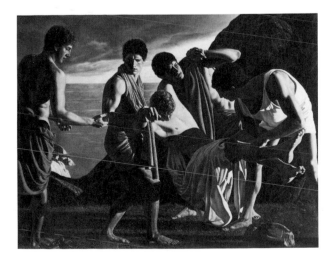

**David Ligare. *Achilles and the Body of Patroclus (The Spoils of War)*. 1984–6. Oil on canvas, 152.4 × 198.1 cm (60 × 78 in).
Courtesy Koplin Gallery, Los Angeles**

In California, a revived classicism seems more naturally attuned to the surroundings than it does in New York. The most elaborate and convinced classical compositions produced by a California-based artist are those of David Ligare (b.1945), who has sometimes been shown in Europe in conjunction with members of the *Pittura Colta* group. Certainly there is a wide range of shared preoccupations, including a desire to find pictorial embodiments for specific aspects of Renaissance and neo-classical art theory. This point is illustrated in *Landscape with a Specific View*. The 'Truth, Utility and Beauty' of the subtitle are the three vital elements which traditional classical taste looked for in art. But Ligare is in thrall to Poussin rather than to Anton Raphael Mengs or to Andrea Appiani, and he is at the same time unmistakably modern. His figures are modern Americans in fancy dress; his Arcadian landscapes have the sharp glitter of Californian light. Once again, it is the sense of anachronism which gives the paintings their piquancy. They acknowledge the cultural fissure which created modernism while rejecting modernism itself.

The mysterious link between California today and the old classical world is further acknowledged in some of the murals painted by Terry Schoonhoven (b.1945), who in his *Study for an Olympic Mural* tellingly contrasts the skyscrapers of the new Los Angeles (one already falling into ruin) with familiar classical artefacts – the Nike of Samothrace and part of the Colosseum. This link is also mysteriously present in paintings which have nothing overtly classical about them, for example in the exquisite, minute, still-life paintings of Nick Boskovich (b.1939), who expresses his reaction against American gigantism by producing miniature universes in which everything is in meticulous order. The use of classical systems of proportion is particularly noticeable in some of these – for example in *Heart Shattered* of 1986.

For a use of classical themes and images quite different

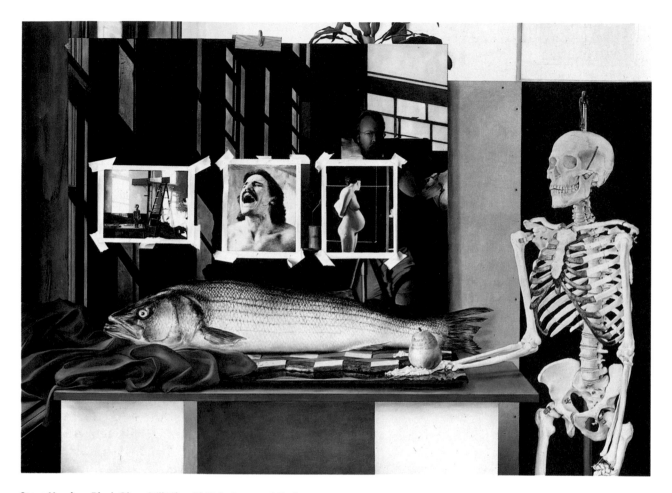

Steve Hawley. *Black Glass Still Life with Fish, Pear and Skeleton.*
1986—8. Oil, wax and alkyd, 108.6 × 152.4 cm (43³/₄ × 60 in).
Courtesy Alexander F. Milliken Inc., New York

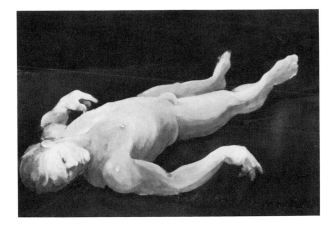

George Dureau. *Fallen Man.* **1989. Oil on canvas, 122 × 177.8 cm (48 × 70 in). Private Collection**

instance, a very strong fascination with the grotesque. The photographs, however, began as documentary studies for his paintings, which convert reality – the reality of people seen in the New Orleans streets – into a dreamlike mythological world, peopled with heroic nudes but also with the hybrids and monsters of Greco-Roman mythology. Appropriately, there is a strong feel of carnival about many of Dureau's recent paintings, and this is combined with a baroque energy which makes some of his canvases the nearest modern equivalent to the frieze of battling gods and giants on the great Altar of Pergamon of the second century BC.

A comparison with the Pergamon Altar seems an appropriate note on which to end, not merely because it fits the work of one artist in particular, but because it was created at a time when art was struggling with problems of pluralism and an almost infinite range of stylistic choice which seem strikingly similar to those difficulties which beset artists today. In the 1980s no one style or way of thinking about art succeeded in dominating the rest, and plurality of styles inevitably led to plurality of judgement – that is, no one set of rules will tell the spectator which artwork is good or important and which is not. More than ever, all artistic judgements became arbitary. The 1980s had nothing even approaching a coherent aesthetic, and all artistic judgements therefore had an *ad hoc* element.

from anything which is happening in Europe, or indeed in New York or in California, one has to turn to the work of the New Orleans artist George Dureau (b. 1930). Dureau has an intense identification with his native city and seldom travels outside it. As a result his reputation has been a thing of slow growth. He first made an impact as a photographer. His photographs combine elements inherited from George Platt Lynes with others which seem to relate to the work of Diane Arbus. Dureau has, for

THE ARTISTS

Note: In spite of all the author's efforts, full information on some artists has proved unobtainable. The numbers at the end of each entry refer to pages. *Illustration references are in italic.*

ABATE, ALBERTO. Italian, b. 1946, Rome, Italy. First solo exhibition in Salerno (1976); has since also exhibited in Rome, Bologna, Milan, Florence, Bari, Alessandria, Trieste, and Taormina. **112;** *109*

ALEXANDER, PETER. American, b. 1939, Los Angeles, USA. Studied at the University of Pennsylvania, the Architectural Association, London, and the University of California, at Berkeley and at Los Angeles (1968). First solo exhibition in New York (1968); has since also exhibited in Dallas, Los Angeles, San Francisco, Corona de Mar, Cal., Akron, Ohio, Munich, Kansas City, San Diego, Irvine, Cal., Santa Ana, Cal., Long Beach, Boulder, Col., La Jolla, Cal., and Chicago. **90;** *91*

ANDREJEVIC, MILET. American, b. 1925, Petrovgrad, Yugoslavia. Studied in Belgrade at the School of Applied Arts and the Academy of Fine Arts (1951). First solo exhibition in Belgrade (1953); has since also exhibited in New York. **117;** *116*

ANTRIM, CRAIG. American, b. 1942. His work has been collected by the Corcoran Gallery of Art, Washington D.C., and institutions in Los Angeles, San Francisco, and Claremont, Cal. **92;** *83*

ARMAJANI, SIAH. American, b. 1939, Tehran, Iran. Has held one-man exhibitions in Philadelphia, Columbus, Ohio, New York, and Kansas City. **101;** *101*

ARNESON, ROBERT. American, b. 1930, Benicia, Cal., USA. Studied at the California College of Arts and Crafts, Oakland, and Mills College, Oakland (1958). First solo exhibition in San Francisco (1967); has since also exhibited in Chicago, Washington D.C., and New York. **100;** *100, 102*

AUERBACH, FRANK. British, b. 1931, Berlin, Germany (acquired British nationality in 1947). Studied in London at the Hampstead Garden Suburb Polytechnic, the Borough Polytechnic (under David Bomberg), St. Martin's School of Art, and the Royal College of Art. First solo exhibition in London (1956). A retrospective of his work was organized by the British Arts Council in 1978. Represented Britain at the 1986 Venice Biennale. **30;** *30, 35*

AYCOCK, ALICE. American, b. 1946, Harrisburg, Penn., USA. First solo exhibition in Halifax, Nova Scotia (1972); has since also exhibited in New York, Cambridge, Mass., and Williamstown, Mass. **101;** *101*

BACON, FRANCIS. British, b. 1909, Dublin, Ireland. Little formal education. Began to paint in 1929, but was not successful until 1945. Represented Britain at the 1954 Venice Biennale. Has exhibited very widely. There have been major retrospectives of his work at the Tate Gallery, London, in 1962 and 1985, at the Solomon R. Guggenheim Museum, New York, in 1963/4, at the Hamburg Kunstverein and the Moderna Museet, Stockholm, in 1965, and at the Grand Palais, Paris, in 1983. **31;** *2*

BASELITZ, GEORG. German, b. (as Georg Kern) 1938, Deutschbaselitz, Germany. Studied at the Hochschule für Bildende und Angewandte Kunste, East Berlin, then at the Hochschule für Bildende Kunste in West Berlin (1964). First solo exhibition in Berlin (1963); has since also exhibited in London, Amsterdam, Braunschweig, Cologne, Eindhoven, Hamburg, Akron, Ohio, Bordeaux, Milan, New York, Basle, Berkeley, Cal., Lyon, Munich, and Vancouver. **15;** *15, 16*

BASQUIAT, JEAN-MICHEL. American, 1960–88, New York, USA. First solo exhibition in New York (1981); has since also taken part in group exhibitions in Lucerne, Kassel, and the Whitney Museum of American Art, New York. **63;** *64*

BATES, DAVID. American, b. 1952, Dallas, USA. Studied at the Southern Methodist University, Dallas (1976). First solo exhibition in Dallas (1976); has since also exhibited in Houston. **81;** *81*

BELLANY, JOHN. British, b. 1942, Port Seton, Scotland. Studied at Edinburgh College of Art and the Royal College of Art, London (1968). First solo exhibition in Holland (1965); has since also exhibited in London, Dublin, Edinburgh, Aberdeen, Glasgow, New York, Melbourne, Perth, Sydney, and Amsterdam. There was a retrospective of his work at the Scottish National Gallery of Modern Art, Edinburgh, and the Serpentine Gallery, London, in 1986. **41;** *41, 42*

BENGSTON, BILLY AL. American, b. 1934, Dodge City, Kans., USA. First solo exhibition in Los Angeles (1958); has since also exhibited in New York, San Francisco, Salt Lake City, Santa Barbara, Hamburg, La Jolla, Cal., Houston, Cologne, Miami, Dallas, Toronto, Washington D.C., Coronado, Cal., Seattle, Chicago, Portland, Missoula, Mont., Thousand Oaks, Cal., Birmingham, Mich., Honolulu, Palo Alto, Cal., Kansas City, and Oakland, Cal. **90;** *90*

BENTON, FLETCHER. American, b. 1931, Jackson, Ohio, USA. Studied at Miami University and Oxford, Ohio (1956). First solo exhibition in New York (1962); has since also exhibited in San Francisco, Brussels, Flint, Mich., Detroit, Portland, Buenos Aires, Caracas, Phoenix, Rio de Janeiro, Milwaukee, Aachen, Offenbach, and Boston. **93;** *93*

BLECKNER, ROSS. American, b. 1949, New York, USA. Studied at New York University and the California Institute of the Arts.

First solo exhibition in New York (1975); has since also exhibited in Chicago, Antwerp, Boston, and Milwaukee. Was included in the 1975 and 1989 Biennials of the Whitney Museum of American Art, New York. **77;** *77, 79*

BONECHI, LORENZO. Italian, b. (as Figline Valdarno) 1955, Florence, Italy. First solo exhibition in Göteborg, Sweden (1984); has since also exhibited in Florence, London, New York, Zurich and Siena. **112;** *112*

BOSKOVICH, NICK. American, b. 1939, San Pedro, Cal., USA. Studied at California State University, Long Beach (1980). First solo exhibition in Muncie, Ind. (1977); has since also exhibited in Los Angeles, Santa Ana, Cal., and Chicago. **117;** *110*

BRAVO, CLAUDIO. Chilean, b. 1936, Valparaiso, Chile. Studied in Santiago with Manuel Venegas Cienfuentes. First solo exhibition in Santiago (1954) and has since also exhibited in New York. Has worked in Spain, the Phillipines, and Morocco. **113;** *113*

BROWN, JOAN. American, b. 1938, San Francisco, USA. Has held one-woman exhibitions in New York, San Francisco, and Chicago. Her work is collected in the Museum of Modern Art, New York, the Albright-Knox Art Gallery, Buffalo, and the County Museum, Los Angeles. **85;** *85*

BROWN, ROGER. American, b. 1941, Hamilton, Ala., USA. Studied at the American Academy of Art, Chicago, and the School of the Art Institute, Chicago (1970). First solo exhibition in Chicago (1971); has since also exhibited in New York, London, Los Angeles, and Atlanta. **80;** *80*

BURTON, SCOTT. American, b. 1939, Greensboro, Ala., USA. Studied with Leon Berkowitz, Washington D.C., and Hans Hoffman, Provincetown, Mass. First solo exhibition in New York (1971); has since also exhibited in Washington D.C., San Francisco, Berkeley, Cincinnati, and Fort Worth. **101;** *101*

CAMPBELL, STEVEN. British, b. 1953, in Glasgow, UK. Studied at Glasgow School of Art (1982). Worked in New York from 1982 to 1986. First solo exhibition in New York (1983); has since also exhibited in Chicago, Munich, London, Edinburgh, Washington D.C., Berlin, Geneva, and San Francisco. **44;** *43, 44*

CHEVALIER, PETER. German, b. 1955, Karlsruhe, West Germany. Studied at the Hochschule für Bildende Kunste, Braunschweig (1980). First solo exhibition in Berlin (1981); has since also exhibited in Düsseldorf, Munich, New York, Freiburg, San Francisco, and Milan. **22;** *22*

CHIA, SANDRO. Italian, b. 1946, Florence, Italy. Studied at the Instituto d'Arte and the Accademia dei Belle Arti, Florence

(1969). First solo exhibition in Rome (1979); has since also exhibited in New York, Amsterdam, Hanover, Berlin, and Paris. His work was featured at the 1988 Venice Biennale. **28;** *23, 25*

CLEMENTE, FRANCESCO. Italian, b. 1952, Naples, Italy. Studied briefly at Rome University. First solo exhibition in Rome (1971); has since also exhibited in Berkeley, Cal., Hanover, Berlin, Sarasato, Fla., Chicago, Madrid, and Basle. Has worked in India and New York. **28;** *24*

COOPER, EILEEN. British, b. 1953, Glossop, Derbs., UK. Studied in London at Goldsmiths' College and the Royal College of Art (1977). First solo exhibition in London (1979); has since also exhibited in Aberdeen, Manchester, and Bath. **54;** *54*

COX, STEPHEN. British, b. 1946, Bristol, UK. First solo exhibition in London (1977); has since also exhibited in Amsterdam, Bari, Florence, and Geneva. **105;** *105*

CRAGG, TONY. British, b. 1949, Liverpool, UK. Studied at Gloucestershire College of Art, Wimbledon School of Art, and the Royal College of Art, London. First solo exhibition in London (1979); has since also taken part in group exhibitions in Metz, Paris, and New York. **104;** *94*

CUCCHI, ENZO. Italian, b. 1949, Moro d'Alba, Italy. Expelled from school aged fifteen, and worked briefly as assistant to a Florentine picture restorer. First solo exhibition in Milan (1979); has since also exhibited in Amsterdam, Madrid, New York, Paris, Bielefeld, and Munich. **28;** *26*

CURRIE, KEN. British, b. 1960, North Shields, Northumb., UK. Studied at Paisley College, and the Glasgow school of Art (1983). First solo exhibition in Glasgow (1983); has since also exhibited in Bristol and London. **45;** *45*

CZERNUS, TIBOR. Hungarian, b. 1927, Kondoros, Hungary (settled in Paris in 1964). Studied at the Budapest Academy of Fine Arts (1952). First solo exhibition in Paris (1964). **113;** *115*

DEACON, RICHARD. British, b. 1949, Wales, UK. Studied in London at St. Martin's School of Art and the Royal College of Art. First solo exhibition in London (1978); has since also exhibited in a number of major international exhibitions. Winner of the Turner Prize in 1987. **106;** *106*

DE FOREST, ROY. American, b. 1930, North Platte, Neb., USA. Studied at the California School of Fine Arts and San Francisco State College (1956). First solo exhibition in San Francisco (1955); has since also exhibited in Yakima, Wash., Los Angeles, New York, Chicago, Paris, Calgary, Fort Worth, Salt Lake City, Boston, Pittsburgh, Philadelphia, Portland, Regina, Saskatchewan,

and many Californian galleries. **85;** *85, 89*

DE STAEBLER, STEPHEN. American, b. 1933, St. Louis, USA. Studied at Princeton University and the University of California (1961). Has exhibited widely in the United States, especially in New York and California. **100;** *101*

DINE, JIM. American, b. 1935, Cincinnati, Ohio, USA. Studied at the University of Cincinnati, Boston Museum School, and Ohio University, Athens. First solo exhibition in New York (1959); has since also exhibited in Milan, Cologne, Paris, Turin, London, Amsterdam, Munich, Toronto, Geneva, and Graz. **97;** *97*

DUREAU, GEORGE. American, b. 1930, New Orleans, USA. Studied at Louisiana State University and Tulane University, New Orleans (1955). First solo exhibition in New Orleans (1977); has since also exhibited in London, Laurel, Miss., Atlanta, and Washington D.C. **119;** *119*

FAULKNER, AMANDA. British, b. 1953, Dorset, UK. Studied at Bournemouth College of Art and Design, Ravensbourne College of Art and Design, and Chelsea School of Art, London. First solo exhibition in London (1983), where she has subsequently held two others. **54;** *53*

FETTING, RAINER. German, b. 1949, Wilhelmshaven, West Germany. Studied at the Hochschule für Kunste, Berlin (1978). Co-founded the co-operative Galerie am Moritzplatz in 1977. First solo exhibition in Berlin (1977); has since also exhibited in Berlin, London, New York, Zurich, Amsterdam, Milan, Stockholm, Brussels, Geneva, Munich, Basle, San Francisco, Cannes, Oslo, Vienna, Wilhelmshaven, and Helsinki. **19;** *10, 19, 20*

FISCHL, ERIC. American, b. 1948, New York, USA. Studied at California Institute of Arts, Valencia (1972). First solo exhibition in Halifax, Nova Scotia (1975); has since also exhibited in Montreal, New York, Akron, Ohio, Toronto, and Boulder, Col. **61;** *61*

FLANAGAN, BARRY. British, b. 1941, Prestatyn, Wales, UK. Studied at St. Martin's School of Art, London (1966). First solo exhibition in London (1966); has since also exhibited in Milan, Kassel, New York, Venice, Sydney, Amsterdam, Paris, Cologne, and Chicago. Represented Britain at the 1982 Venice Biennale, **107;** *108*

FRANCIS, SAM. American, b. 1923, San Mateo, Cal., USA. Studied at the University of California, Berkeley, and the Académie Fernand Léger, Paris. First solo exhibition in Paris (1952); has since also exhibited in New York, London, Frankfurt, Tokyo, Berkeley, Los Angeles, and Bern. **85;** *90*

FREUD, LUCIAN. British, b. 1922, Berlin, Germany (acquired British nationality in 1939). Studied in London at the Central School of Art and Goldsmiths' College, and briefly with Cedric Morris and Lett Haines in Suffolk. First solo exhibition in London (1944). There have been retrospectives of his work at the Hayward Gallery, London, in 1974, and a travelling exhibition in 1987/8. **30;** *33*

FREY, VIOLA. American, b. 1933, Lodi, Cal., USA. Studied at Tulane University, New Orleans. First solo exhibition in San Francisco (1974); has since also exhibited in La Jolla, Cal., Kansas City, and Los Angeles. **100;** *100, 103*

GILBERT AND GEORGE. Gilbert, British, b. 1943, Dolomites, Italy. Studied at Wolkenstein and Hallein Schools of Art, and Munich Academy. George, British, b. 1942, Devon, UK. Studied at Dartington Hall College of Art and Oxford College of Art. They both studied at St. Martin's School of Art, London, in 1967, and have since held over 140 two-man and 95 group exhibitions. **37;** *40*

GORMLEY, ANTHONY. British, b. 1950, London, UK. First solo exhibition in London (1981); has since also exhibited in Cardiff, New York, and Munich. **106;** *106*

GRAHAM, ROBERT. American, b. 1938, Mexico City, Mexico. Studied at San José State College, Cal., and the San Francisco Art Institute (1964). First solo exhibition in Hamburg (1970); has since also exhibited in Cologne, Berlin, London, New York, Frankfurt, Dallas, Los Angeles, Houston, Zurich, St. Louis, and Minneapolis. **97;** *97*

HALLEY, PETER. American, b. 1953, New York, USA. Studied at Yale University and the University of New Orleans. First solo exhibition in New Orleans (1978); has since also exhibited in New York, Paris, and Los Angeles. Was included in the 1987 Biennial of the Whitney Museum of American Art, New York. **72;** *78*

HARING, KEITH. American, b. 1958, Kutztown, Penn., USA. Studied at the School of Visual Arts, New York (1979). First solo exhibition in New York (1981); has since also exhibited in Venice, Cal., Rotterdam, Tokyo, Naples, and Hartford, Conn. **66;** *66*

HARRISON, HELEN MAYER, AND NEWTON. American, b. 1929 & 1932, New York City, USA. First joint exhibition in Fullerton, Cal. (1972). Have since also exhibited in Los Angeles, New York, Detroit, Washington D.C., Portland, Williamstown, Mass., Providence, R.I., Chicago, Baltimore, Atlanta, San José, Pasadena, Irvine, Cal., Little Rock, Ark., Ithaca, NY, Palomar, Cal., Toronto, Las Vegas, Wichita, Kans., Boulder, Co., Pomona, Cal., Berlin, and Laguna Beach. **91;** *92*

HAWLEY, STEVE. American, b. 1950, Brooklyn, NY, USA.

Studied Museum of Fine Arts, Boston (1973). He has exhibited in Boston, Mass. (1978) and in New York at Alexander F. Milliken (1981, 1984). **117;** *118*

HODGKIN, HOWARD. British, b. 1932, London, UK. Studied at the Camberwell School of Art and the Bath Academy of Art, Corsham (1956). Represented Britain at the 1984 Venice Biennale; the exhibition was later transferred to the Whitechapel Art Gallery, London. Winner of the Turner Prize in 1985. **31;** *36, 39*

HOWSON, PETER. British, b. 1958, London, UK. Studied at the Glasgow School of Art (1979), Artist in residence at St. Andrews University (1985). First solo exhibition in London (1982); has since also exhibited in Glasgow and St. Andrews. **45;** *44*

IMMENDORF, JORG. German, b. 1945, Bleckede, West Germany. Studied at the Kunstakademie, Düsseldorf (1964), and later with Joseph Beuys. First solo exhibition in Cologne (1978); has since also exhibited in Bern, Eindhoven, Cologne, Düsseldorf, Munich, New York, Paris, London, Milan, Oxford, Zurich, Chicago, and Braunschweig. **15;** *17*

IRWIN, ROBERT. American, b. 1928, Long Beach, Cal., USA. Studied in Los Angeles at the Otis Art Institute, the Jepson Art Institute, and the Chouinard Art Institute. First solo exhibition in Los Angeles (1957); has since also exhibited in Pasadena, Cal., New York, Minneapolis, Paris, Cambridge, Mass., Dayton, Ohio, and Santa Barbara, Cal. **91**

JACKLIN, BILL. British, b. 1943, London, UK. Studied at Walthamstow School of Art and the Royal College of Art, London (1967). Has also worked as a graphic designer. First solo exhibition in London (1970) and has since also exhibited in New York. **36;** *32*

JACKOWSKI, ANDRZEJ. British, b. 1947, Penley, Wales, UK. Studied at Camberwell College of Art, Falmouth College of Art, and the Royal College of Art, London (1977). First solo exhibition in Guildford, Surrey (1978); has since also exhibited in London and Liverpool. **48;** *49*

KAPOOR, ANISH. British, b. 1954, Bombay, India. First solo exhibition in Paris (1980); has since also exhibited in London, Liverpool, Rotterdam, and Lyons. Chosen to represent Britain at the 1990 Venice Biennale. **105;** *99*

KEANE, JOHN. British, b. 1954, Hertfordshire, UK. Studied at Camberwell School of Art 1972–6. Artist in residence at Whitefield School, London, 1987; has held six one-man exhibitions in London since 1980. **49;** *49*

KIEFER, ANSELM. Germany, b. 1945, Donaueschingen, West Germany. Studied at Freiburg and Karlsruhe, then under Joseph

Beuys at Düsseldorf from 1970 to 1972. First solo exhibition in Karlsruhe (1969); has since also exhibited in Groningen, Cologne, Essen, London, Freiburg, Milan, New York, Rotterdam, Bordeaux, Düsseldorf, Chicago, and Philadelphia. Represented West Germany at the 1980 Venice Biennale. There was a retrospective of his work, shared by the Art Institute, Chicago, the Philadelphia Museum of Art, and the Museum of Modern Art, New York, in 1987. **15;** *18*

KIRBY, JOHN. British, b. 1949, Liverpool, UK. After various types of employment, studied in London at St Martin's School of Art and the Royal College of Art. **54;** *54*

KOONS, JEFF. American, b. 1955, York, Penn., USA. Studied at the Maryland Institute College of Art, Baltimore, and the School of the Art Institute, Chicago. First solo exhibition in New York (1980); has since also exhibited in Chicago, and Los Angeles. Was included in the 1989 Biennial of the Whitney Museum of American Art, New York. **76;** *76*

KOSSOFF, LEON. British, b. 1926, London, UK. Studied in London at St. Martin's School of Art, the Borough Polytechnic (under David Bomberg), and the Royal College of Art (1956). First solo exhibition in London (1957); has since also exhibited in Oxford, Venice, California, and New York. There was a retrospective of his work at the Whitechapel Art Gallery, London, in 1974. **31;** *31, 34*

KOUNELLIS, JANNIS. Greek, b. Greece. First solo exhibition in Rome (1960); has since also exhibited in Milan, Turin, Naples, Paris, West Berlin, New York, Cologne, Athens, Bordeaux, Krefeld, Munich, London, Chicago, Düsseldorf, and Bath. *8*

KRUT, ANSEL. British, b. 1959, Cape Town, South Africa. Studied at the University of Witwatersrand, Johannesburg, and the Royal College of Art, London (1986). First solo exhibition in Johannesburg (1984); has since also exhibited in London and Rome. Winner of the Prix de Rome in 1986–7. **54;** *55*

LEONARD, MICHAEL. British, b. 1933, Bangalore, India. Worked from 1957 to 1972 as an illustrator. Held one-man exhibitions in 1977 in New York and London. There was a retrospective of his work at the Gemeente Museum, Arnhem, Netherlands in 1977–8. His work is collected in the Boymans-von Beuningen Museum. **116;** *116*

LE BRUN, CHRISTOPHER. British, b. 1951, Portsmouth, Hants., UK. Studied in London at the Slade School of Art and the Chelsea School of Art (1975). First solo exhibition in London (1980); has since also exhibited in Paris, New York, Edinburgh, Basle, Stromness (Orkney), Berlin, and Cologne. **48;** *48*

LIGARE, DAVID. American, b. 1945, Oak Park, Ill., USA.

Studied at the Art Center College of Design, Los Angeles. First solo exhibition in New York (1969); has since also exhibited in Monterey, Phoenix, and Los Angeles. **117; *117***

LONG, RICHARD. British, b. 1946, Bristol, UK. Studied at the West of England College of Art and St Martin's School of Art, London (1968). First solo exhibition in Düsseldorf (1968); has also exhibited in New York, Paris, Milan, Amsterdam, London, Antwerp, Edinburgh, Basel, Rome, Tokyo, Bern, Melbourne, Sydney, Hamburg, Zurich, Eindhoven, Athens, Toronto, Bordeaux, Los Angeles, Ottawa, Naples, Dallas, Malmö, Porin, Geneva, Chicago, Grenoble, Aachen, St. Gallen, Chagny, and several British cities. Represented Britain at the 1976 Venice Biennale. **104; *104***

McKEEVER, IAN. British, b. 1946, Withersea, Yorks., UK. Studied at Avery Hill College of Education. First solo exhibition in Cardiff (1973); has since also exhibited in London, Venice, Newcastle, Trieste, Warsaw, Bristol, Glasgow, Liverpool, Oxford, Nuremberg, Düsseldorf, Munich, Southampton, Vienna, Cologne, Stuttgart, Helsinki, Innsbruck, Hamburg, Braunschweig, Preston, Hasselt, and Zurich. **48; *50***

McKENNA, STEPHEN. British, b. 1939, London, UK. Studied at the Slade School of Art, London (1964). First solo exhibition in London; has since also exhibited in Frankfurt, Munich, Brussels, Antwerp, Berlin, Oxford, Düsseldorf, Eindhoven, and Milan. **113; *111***

McLEAN, BRUCE. British, b. 1944, Glasgow, UK. Studied at Glasgow School of Art and at St. Martin's School of Art, London. Formed Nice Style, 'the World's First Pose Band', in 1971. Winner of the John Moores Prize in 1985. **37; *37, 38***

MAPPLETHORPE, ROBERT. American, 1946–89. First solo exhibition in New York (1976); has since also exhibited in Washington D.C., Paris, San Francisco, and Norfolk, Va. His work was included in the 1977 Kassel Documenta. **68; *68, 69***

MARIANI, CARLO MARIA. Italian, b. Rome, Italy. Studied at the Accademia dei Belle Arti, Rome. First solo exhibition in Rome (1973); has since also exhibited in Bologna, Milan, Rome, Cologne, Naples, Turin, Florence, New York, Paris, Munich, Long Beach, and Los Angeles. **109; *114***

MISTRY, DHRUVA. British, b. 1957, Kanjari, India. Studied at the University of Baroda and the Royal College of Art, London (1983). First solo exhibition in New Delhi (1981); has since also exhibited in Bombay, Ahmedabad, and Cambridge. **105; *98, 105***

MORLEY, MALCOLM. American, b. 1931, London, UK (emigrated to USA in 1958). Studied in London at Camberwell School of Arts and Crafts and the Royal College of Art. He held a

one-man exhibition in New York (1968). His work has been collected in the Whitney Museum of American Art, New York. **57; *60***

MOROLES, JESUS BAUTISTA. American, b. 1950, Corpus Christi, Texas, USA. Studied at El Centro College, Dallas, and the North Texas State University, Denton (1978), and as an apprentice to Luis Jimenez. Worked in Carrara, Italy, from 1979 to 1980. First solo exhibition in Santa Fé (1981); has since also exhibited in Dallas, Houston, Victoria, Texas, San Antonio, and Corpus Christi, Texas. **96; *96***

NILSSON, GLADYS. American, b. 1940, Chicago, USA. Studied at the School of the Art Institute, Chicago (1962). First solo exhibition in San Francisco (1969); has since also exhibited in Chico, Cal., Folsom, Cal., New York, Chicago, Madison, Portland, and Winston-Salem, N.C. **80; *80***

NUTT, JIM. American, b. 1938, Pittsfield, Mass., USA. Studied at the School of the Art Institute, Chicago (1965). First solo exhibition in Folsom, Cal. (1971); has since also exhibited in Chicago, New York, Minneapolis, Portland, San Francisco, and Rotterdam. **80; *82***

OULTON, THÉRÈSE. British, b. 1953, Shrewsbury, Shrops., UK. Studied in London at St. Martin's School of Art and the Royal College of Art (1983). First solo exhibition in Oxford (1985); has since also exhibited in Vienna, Munich, Berlin, New York, and London. **48; *51***

PALADINO, MIMMO. Italian, b. 1948, Paduli, Italy. Studied at Benevento School of Art. First solo exhibition in Naples (1977); has since also exhibited in Karlsruhe, Basle, Oslo, Munich, Richmond, Va., and Milan. There was a retrospective of his work at the Lenbachhaus, Munich, In 1985. **29; *6, 27, 28***

PASCHKE, ED. American, b. 1939, Chicago, USA. Studied at the School of the Art Institute, Chicago (1970). First solo exhibition in Edinburgh (1973); has since also exhibited in Cincinnati, Philadelphia, Chicago, Paris, Pittsburgh, and Kalamazoo. **80; *86***

POIRIER, ANNE AND PATRICK. French, b. 1942, Marseilles and Nantes, France. Have worked together since 1970, with joint exhibitions in Paris, Cologne, Berlin, Bonn, Mannheim, New York, and London. **112; *112***

ROTHENBERG, SUSAN. American, b. 1945, Buffalo, N.Y., USA. Has held four solo exhibitions in New York (1975), and contributed to several group exhibitions. Her work has been collected in the Museum of Modern Art, New York, and the Albright-Knox Art Gallery, Buffalo. **60; *60***

RUSCHA, ED. American, b. 1937, Omaha, Neb., USA. Studied at

the Chouinard Art Institute, Los Angeles (1960). First solo exhibition in Los Angeles (1963); has since also exhibited in New York, Munich, London, Cologne, Milan, Clinton, N.Y., Houston, Toronto, Grand Forks, N. Dak, and Tempe, Ariz, **90;** *87*

SALLE, DAVID. American, b. 1952, Norman, Okl., USA. Studied at the California Institute of Arts, Valencia (1975). First solo exhibition in Los Angeles (1975); has since also exhibited in New York, Groningen, Amsterdam, and Zurich. **57;** *59*

SAUL, PETER. American, b. 1934, San Francisco, USA. First solo exhibition in New York (1972); has since also exhibited in Chicago, Los Angeles, Rome, Turin, Cologne, Paris. His work has been collected in the Museum of Modern Art, New York, the Art Institute, Chicago, and the Whitney Museum of American Art, New York. **81;** *88*

SCHARF, KENNY. American, b. 1958, Los Angeles, USA. Studied at the School of Visual Arts, New York (1980). First solo exhibition in New York (1979); has since also exhibited in Long Island City, NY. **67;** *65, 67*

SCHINDLER, THOMAS. German, b. 1959, Braunschweig, West Germany. Studied at the HBK in Braunschweig (1984). First solo exhibition in Hannover (1981); has since also exhibited in Berlin, New York, San Francisco, Valencia, Paris, Brussels, Milan and London. **22;** *22*

SCHNABEL, JULIAN. American, b. 1951, New York, USA. Studied at the University of Houston, and the Whitney Museum of Modern Art (1974). First solo exhibition in Houston (1979); has since also exhibited in New York, San Francisco, Zurich, Chicago, Los Angeles, Amsterdam, and London. **56;** *58*

SCHOONHOVEN, TERRY. American, b. 1945, Freeport, Ill., USA. Studied at the University of Wisconsin and the University of California, Los Angeles (1969). First solo exhibition in Newport Beach, Cal., (1975); has since also exhibited in Colorado Springs, Tempe, Ariz., Sacramento, Chico, Cal. Los Angeles, and Sydney. **117;** *117*

SCHUYFF, PETER. American, b. 1956, Baarn, Netherlands. First solo exhibition in White Columns, N.Y. (1983); has since also exhibited in New York, Los Angeles, Geneva, Naples, and Cologne. **72;** *72, 75*

SEGAL, GEORGE. American, b. 1924, New York, USA. Studied at the Pratt Institute of Design, New York, New York University, and Rutgers University, New Brunswick, N.J. (1963). First solo exhibition in New York (1956); has since also exhibited in Paris, Düsseldorf, Chicago, Zurich, Tokyo, and Jerusalem. **96;** *95*

SHERMAN, CINDY. American, b. 1945. Studied at the State University of New York (1975). First solo exhibition in Houston (1980); has since also exhibited in Amsterdam, Missouri, St. Etienne, Tokyo, Amherst, Mass., and Akron, Ohio. **70;** *71*

STEINBACH, HAIM. American, b. 1944, Israel. Studied at the Pratt Institute, New York, and Yale University, New Haven, Conn. First solo exhibition in New Haven, Conn. (1973); has since also exhibited in New York, Pittsfield, Washington D.C., and Chicago. **76;** *73*

TAAFFE, PHILIP. American, b. 1955, Elizabeth, N.J., USA. Studied at Cooper Union, New York. First solo exhibition in New York (1982); has since also exhibited in Hamburg, and Cologne. Was included in the 1987 Biennial of the Whitney Museum of American Art, New York. **72;** *72, 74*

WARRENS, ROBERT. American, b. 1933, Sheboygan, Wisc., USA. Studied at the University of Wisconsin, Milwaukee, and the State University of Iowa, Ames. First solo exhibition in New Orleans (1972); has since also exhibited in Chicago, New York, Washington D.C., and Baton Rouge, La. **84;** *84*

WASHMON, GARY. American, b. 1955, Tucson, Ariz., USA. Studied at the University of New Mexico, Albuquerque, and the University of Illinois (1978). First solo exhibition in Georgetown, Texas (1981); has since also exhibited in Lafayette, La., and Austin. **84;** *84*

WEBER, BRUCE. American, b. 1946. Studied at the New School, Hun School, Princeton, N.J., and Denison University, Ohio. First solo exhibition in New York (1974); has since also exhibited in Los Angeles, and Chicago. **70;** *70*

WILKINS, WILLIAM. British, b. 1938. Studied at Swansea College of Art and the Royal College of Art, London. First solo exhibition in Aberystwyth, Wales (1970); has since also exhibited in Cardiff, London, Warsaw, Swansea, New York, Palm Beach, and San Francisco. **113;** *113*

WILLIAMS, GLYNN. British, b. 1939, Shrewsbury, Shrops., UK. Studied at Wolverhampton College of Art (1955). First solo exhibition in London (1967); has since also exhibited in Hull, Sheffield, Leeds, Wakefield, Cardiff, and Bath. **107;** *107*

YOAKUM, JOSEPH. American, 1886–1976, Navajo Reservation, Arizona, USA. Ran away from home in 1901 and joined Adams Forpaugh Circus. 1918 served in US Army, France. First exhibited his work in c. 1966. First solo exhibition in Chicago (1967); has since exhibited in Pennsylvania, California, New York and Chicago. Died in Chicago, 1976. **80;** *81*

BIBLIOGRAPHY

Art of Our Time: The Saatchi Collection (4 vols). Lund Humphries, London, in association with Rizzoli, New York

Sister Wendy Beckett, *Contemporary Women Artists*. Phaidon, Oxford, 1988

Britannica: Trente Ans de Sculpture. L'Etat des Lieux, Normandy, 1988

Dan Cameron, *New York Art Now: The Saatchi Collection*. Giancarlo Politi Editore n.d., 1988

The Classic Tradition in Recent Painting and Sculpture. Catalogue of an exhibition held at the Aldrich Museum of Contemporary Art, Ridgeford, Conn., 19 May–1 Sept 1985

Tony Godfrey, *The New Image: Painting in the 1980s*. Phaidon, Oxford, 1986

Bruce Guenther, *50 Northwest Artists*. Chronicle Books, San Francisco, 1983

Henry Hopkins, *50 West Coast Artists*. Chronicle Books, San Francisco, 1981

Wolf Jahn, *The Art of Gilbert & George*. Thames & Hudson, London, 1989

Laurel Jones (ed), *50 Texas Artists*. Chronicle Books, San Francisco, 1986

Thomas Krems, Michael Govan, Joseph Thompson (eds), *Refigured Painting: The German Image, 1960–88*. Prestel, in association with the Solomon R. Guggenheim Museum, New York, 1989

Edward Lucie-Smith, *American Art Now*. Phaidon, Oxford, and William Morrow Inc., New York, 1985

Edward Lucie-Smith, Carolyn Cohen, Judith Higgins, *The New British Painting*. Phaidon, Oxford, in association with the Contemporary Arts Center, Cincinnati, 1988

Italo Mussa, *La Pittura Colta*. De Luca Editore, Rome, 1983

A New Spirit in Painting. Catalogue of an exhibition held at the Royal Academy of Arts, London, 15 January–18 March 1981

Mark Rosenthal, *Anselm Kiefer*. The Art Institute of Chicago and Philadephia Museum of Art, 1987 (distributed by Prestel-Verlag)

The Vigorous Imagination: New Scottish Art. Catalogue of an exhibition held at the Scottish National Gallery of Modern Art, Edinburgh, 9 August–25 October 1987

INDEX